Vanishing East End

MEGAN HOPKINSON

AMBERLEY

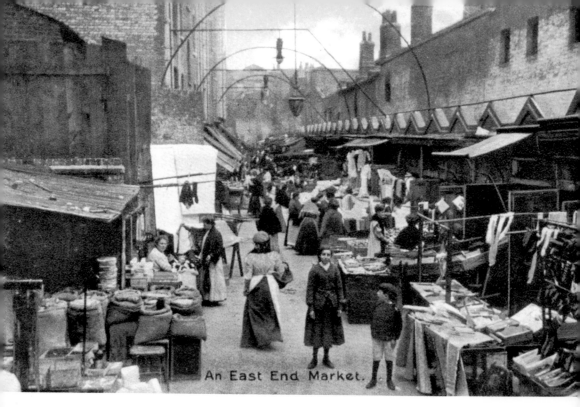

An East End market. (*Courtesy of Michael Foley*)

In loving memory of Nanna and Grandad. You left fingerprints of grace
on my life and loving memories too. You shan't be forgotten.

Frederick John McAllister 13/09/1930 – 14/06/2003
Beryl Lillian McAllister 23/03/1933 – 07/04/2011

First published 2014

Amberley Publishing
The Hill, Stroud, Gloucestershire, GL5 4EP
www.amberley-books.com

Copyright © Megan Hopkinson, 2014

The right of Megan Hopkinson to be identified as the
Author of this work has been asserted in accordance with
the Copyrights, Designs and Patents Act 1988.

ISBN 978 1 4456 0296 7

British Library Cataloguing in Publication Data.
A catalogue record for this book is available from the
British Library.

Typesetting by Amberley Publishing.
Printed in Great Britain.

Contents

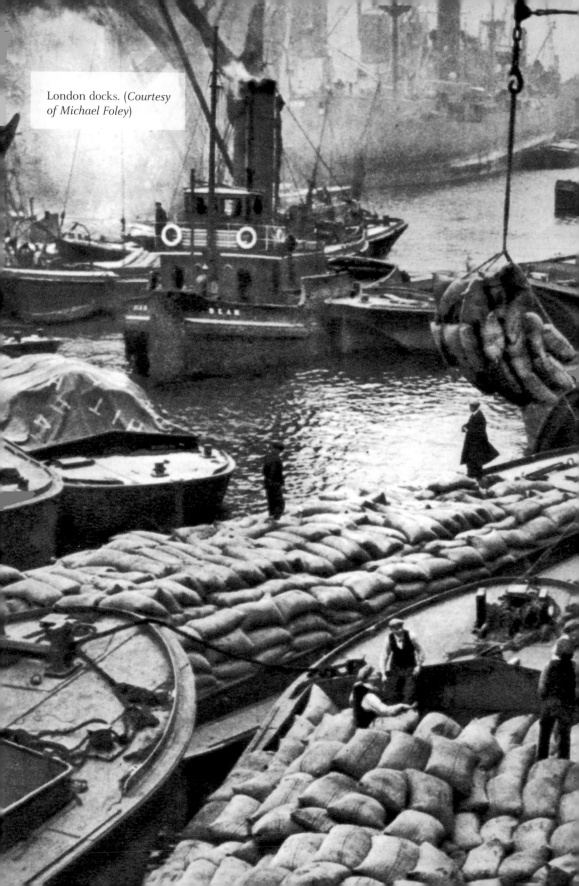

London docks. (*Courtesy of Michael Foley*)

Introduction

Vanishing East End was born from a decision to create a documentary photograph book with memories and stories dedicated to Canning Town (my home town and an area I hold much love and respect for), and the areas surrounding it such as Stratford, Plaistow and East Ham.

Growing up in the East End of London, I witnessed many changes occurring in the surrounding areas of Canning Town. It was particularly fascinating to watch the transformation of the area when London won the bid for the 2012 Olympics. Writing this book not only allowed me to delve into the history of the East End, but to look into the future of the area as well. This study explores East End traditions such as the lingo (Cockney rhyming slang), the pie and mash shops, and the traditional East End pubs, born within the sound of Bow Bells. This book also shares some of the East End's precious memories and moments.

Certain people have been kind enough to allow their interesting life stories of growing up in the area to be published in this book. Many members of my family were also kind enough to share their stories, including tales of life during the war, getting married and the family life that followed, and growing up in the East End of London during wonderful times like the 1930s and onwards. They were able to describe to me what the East End looked like when they were growing up in comparison to how it is now.

There have been many transformations between the different decades, both physically and socially. Not only have my family helped make this book possible, but so have my friends and my family's friends, and they have contributed their views and opinions on living in the area and how growing up in the East End of London has affected their outlook on life.

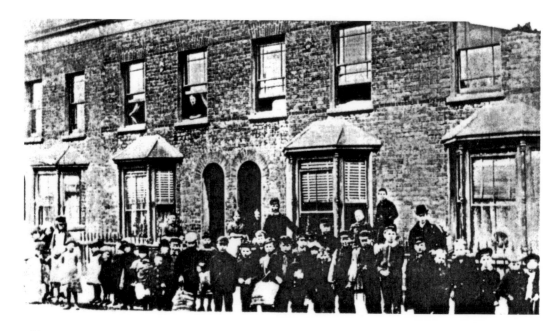

Old Canning Town and the Custom House, Star Lane, pictured here around 1900.

The site of Thames Ironworks, close to Canning Town station.

1

Christine Summer's Story

Christine Summer was born in Malmesbury Road, Canning Town.

The first memory I've got is living in Park Avenue, East Ham, in my grandfather's greengrocer's shop. I used to take lettuce leaves to the old lady next door and she used to give me sweets. However, I was born in No. 55 Malmesbury Road, Canning Town. My mother, Rose, must have moved there at some point in between times. My two elder sisters, Patsy and Maureen, went to school in Nelson Street, but I was not old enough. Then we moved back again to No. 55.

I'll always remember we kept chickens and rabbits. My father, Syd, fattened them up to eat. Everybody kept chickens and rabbits in those days because money was short all the time. Most people would have a lodger; the owner of the home did their laundry and gave them a meal, and the money from the lodger paid the rent. You either had the whole house or half of the house, depending on the amount of people living there. Although money was very short, a lot of people still had parties at the weekend. You could always hear people singing and playing the piano.

My granny and Eileen (my mum's sister) were both classed as invalids. My granny was crippled with arthritis. She couldn't get out of bed and we all used to wait on her. We all used to sit around the radio together listening to plays.

When I was ten years old, I got my first job down Rathbone Street. I worked for a Jewish woman selling costume jewellery. I used to be there from 8 a.m. until 6 p.m. I remember it used to be freezing cold. I thought I was well off because I got a ten shilling note, but I had to work hard for it.

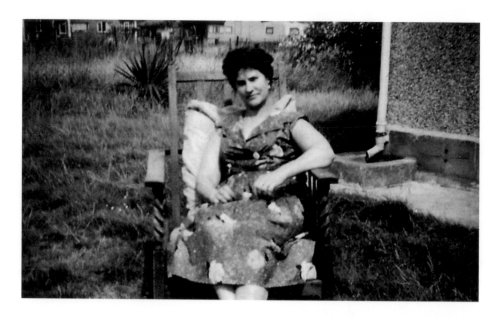

Christine's mother, Rose, at Canvey Island, Cockney Playground. 'Just resting my plates of meat, before I go down to the rubba-dub-dub, for a nice, cold pig's ear,' was a common saying for Christine's mother.

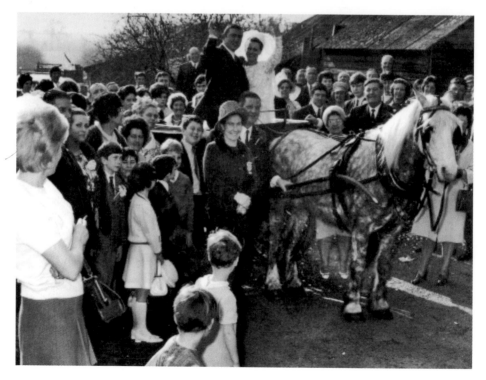

A family wedding.

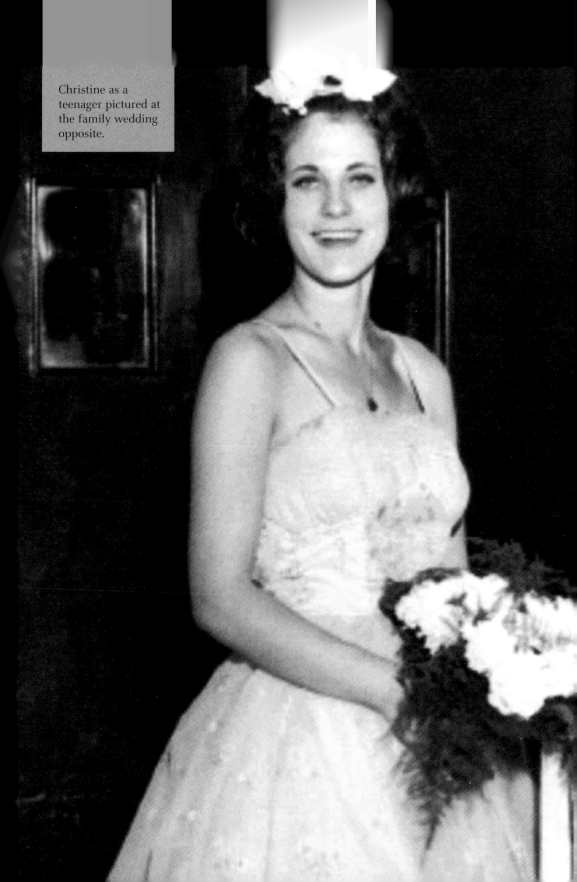

Christine as a teenager pictured at the family wedding opposite.

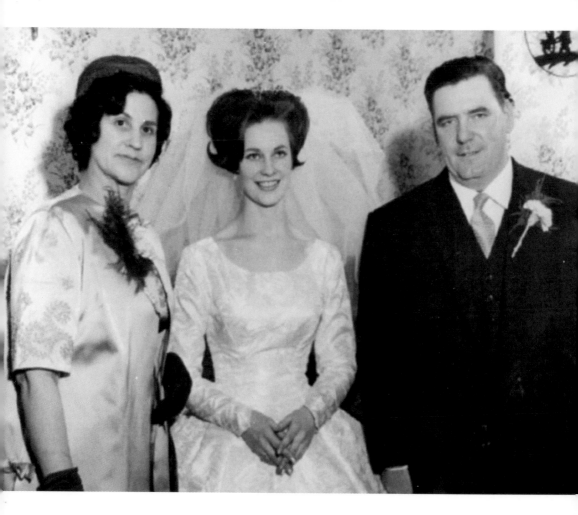

Christine's father, Syd. Most of the men worked in the docks or the factories. My father was always a 'rag and bone' man. When I was very young, all he had was a barrow so he used to walk around the streets with it. Even though people were very poor they always had a few rags to throw away. This was for money, balloons or jam jars. When my dad had enough money, he bought a horse and cart and then went out with that. My mum said that my dad could sell stones because he could sell anything to anyone. He used to bring home a massive big cardboard box full of odd socks. We used to pair them up and sell them week after week down Rathbone Street. It was a smashing market; it was very large, and you could find and buy anything there.

When I was younger we never had any toys, but we used to have a puppy each. My dad always kept a dog, so when they had puppies we used to wrap them up in a cover and pretend they were dolls until they got too big. Then my dad used to sell the puppies on or give them away to others. My grandfather had a black greyhound. It had fourteen puppies once and used to live with us.

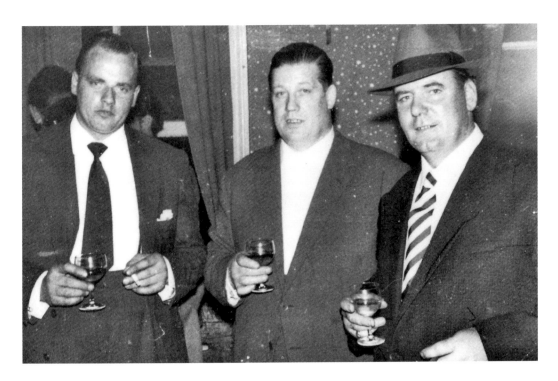

Pictured above are Syd and George, in a pub in Barking. In the fine weather my dad use to take us on the horse and trap to the pub – the Ship & Shovel. We thought it was the country between Barking and Dagenham. Below, Drakies Pub, Canning Town, 1958.

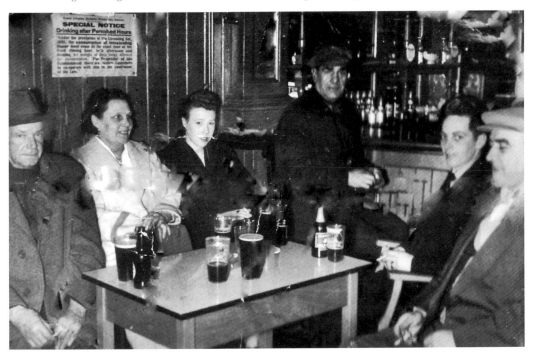

Beryl McAllister's Story

Beryl McAllister, aged seventy-eight, remembers living in the East End of London through the Blitz: 'When that flame went out, you knew it was going to drop!'

I'm originally from East Ham. Later in life I moved to Plaistow, where my husband and I had a family. When he passed away I decided to down size from a townhouse and moved to Canning Town. Seventy-eight years I've lived in the East End of London. However, I have always liked the idea of living in the Kent countryside – a place called Gould Hurst. This area was very nice; we used to work in the hop fields during September, while we were on holiday.

My childhood was spent during the war. I was six years old when the war started and twelve years old when it finished; I still had to turn up to school even though it was going on.

When I was younger we used to go ballroom dancing on Saturday nights at the East Ham town hall. I went with my cousins and we use to pay around half a crown – five shillings. There were live bands that we used to foxtrot too.

There was this one experience that had encapsulated my life. One afternoon my mum was picking us up from school, the siren went and a doodlebug came over, which followed my mum all the way to the school. As she got nearer to the school the fire went out; when that flame went out you knew it was going to drop! Luckily enough the doodlebug dropped in the next turning to the school.

One of my childhood memories was when my mum used to take my younger sister and I to the cinema. When we got inside the cinema the siren would go off and we would have to stay there until the end. We had to wait for the siren to go off again to know it was safe. When we had the 'all clear' we would return home. This always used to happen to us when we went to the East Ham Granada.

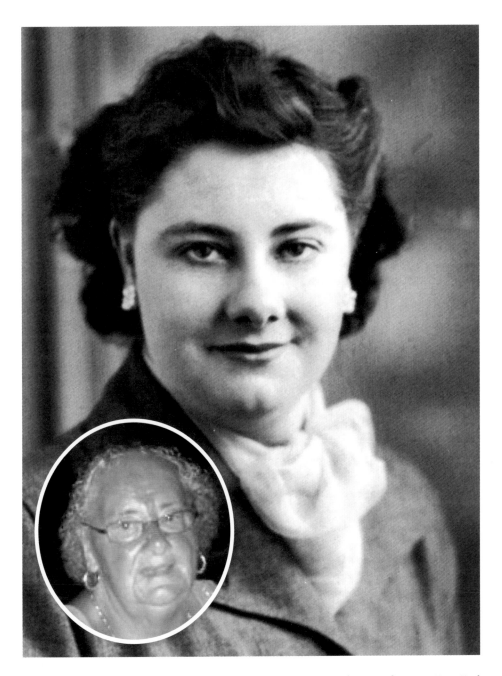

Today's East End looks completely different to how I remember it. The new East End looks more upmarket. However, it is taking away the East End heritage and the sense of community that it was known for. When I heard about East London hosting the 2012 Olympics I thought this event could be very uplifting for the East End, as it would be something that we will never see again plus it should boost tourism and local businesses.

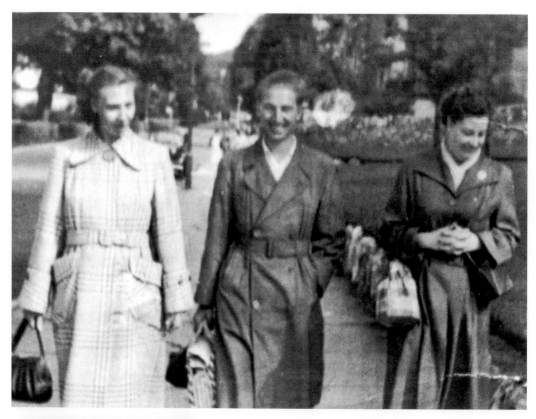

Beryl McAllister, pictured with her
cousins, in her early twenties.

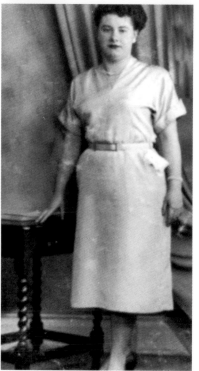

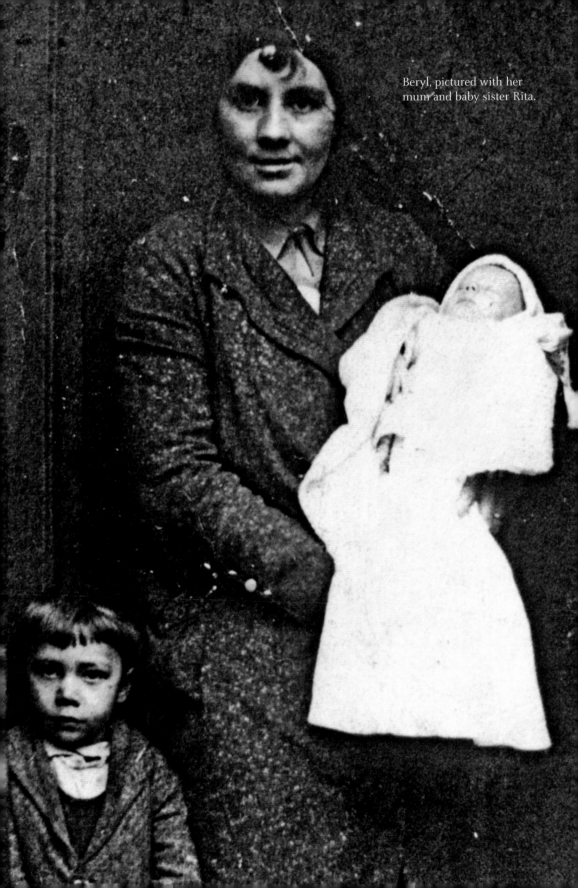

Beryl, pictured with her mum and baby sister Rita.

One of my most memorable childhood holiday memories was when we used to visit the hop fields. One day I remember we went hop picking in the fields and the siren went off. We had to dive underneath these large metal bins because we were being machine-gunned by the Germans. Then the Brits returned fire and the German pilots were hit. This was known as a dogfight. The Germans ejected from the planes and landed in the hop fields with their parachutes. One landed right in front of the pathway where we were sitting.

On a lighter note, one of my funniest childhood memories was when I was ten years old and my cousins and I got chased by a local farmer; we were scrumping the apples from his orchards. This occurred because of the rations and we hadn't seen fruit for a while.

Furthermore, my worst childhood memory was when we were evacuated from the hop fields in Kent and were sent to Newcastle for our safety. My mum didn't like the people we were staying with; they were very unhygienic. She came down one morning to get us a couple of glasses of water and found the one of the female residents urinating in the milk jug – she was using it as a toilet! That was the final straw for my mum; she said, 'right that is it,' and we packed our bags and returned home.

When I was about twenty-one years old, I met my future husband William (Bill) at the dance hall; it amazed me that he asked me to dance because he was such a wonderful dancer, especially being a ballroom dance teacher. When the dance was over he asked me if I would like to go out on a date with him; he took me to the Odeon cinema at the Boleyn on the Sunday.

After our first date our relationship progressed, and on 10 August 1957 we got married at St Mary Magdalene church in East Ham, which now is a nature reserve. We did have a typical church wedding. On our wedding day I was dressed in all white, while my husband was wearing a blue suit. We had five bridesmaids and one pageboy.

We travelled by a posh wedding car, a black limousine in fact. After the church service we travelled back to Roman Road where our reception was held. At the reception we had a disco where everyone was dancing to rock and roll. We were drinking beer and sherry, and we were eating typical East End seafood such as jellied eels, cockles, winkles and shrimp. I could sum up our wedding reception as a good old East End knees-up.

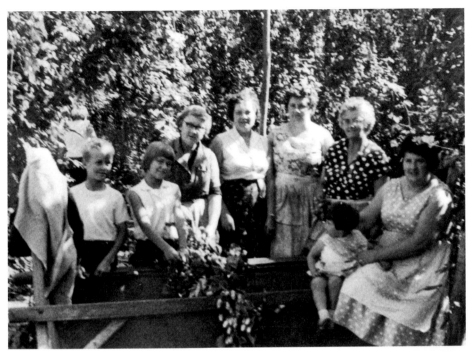

Beryl McAllister on a hop-picking
family holiday in Kent.

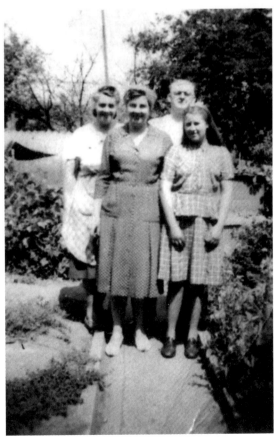

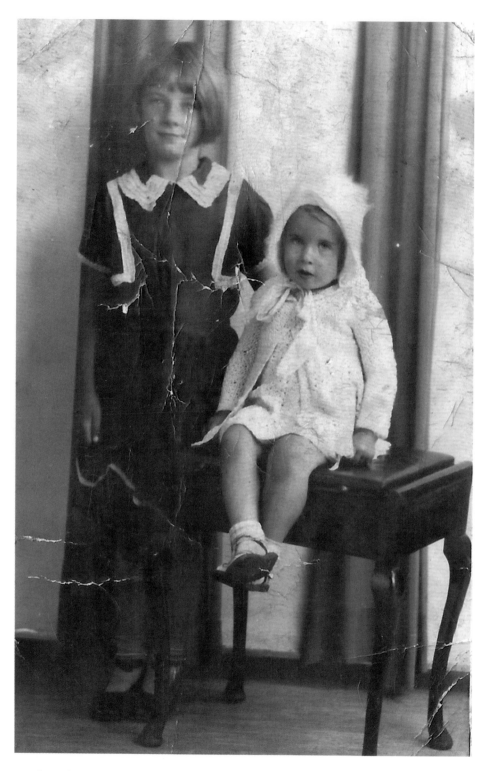

Beryl McAllister, aged ten years old, with her sister Rita Eales, aged four years old, posing for their family portrait photograph.

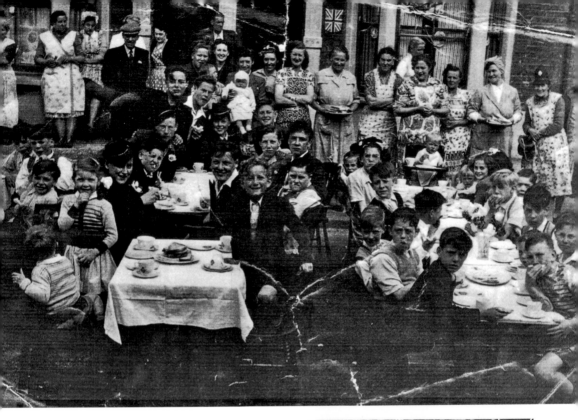

Above: A local street party.

Right: Rita Eales with her dog outside No. 49 Roman Road, East Ham.

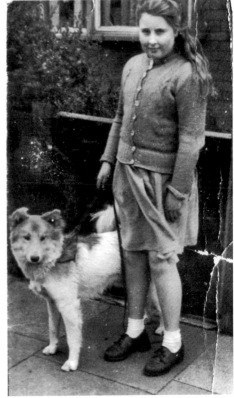

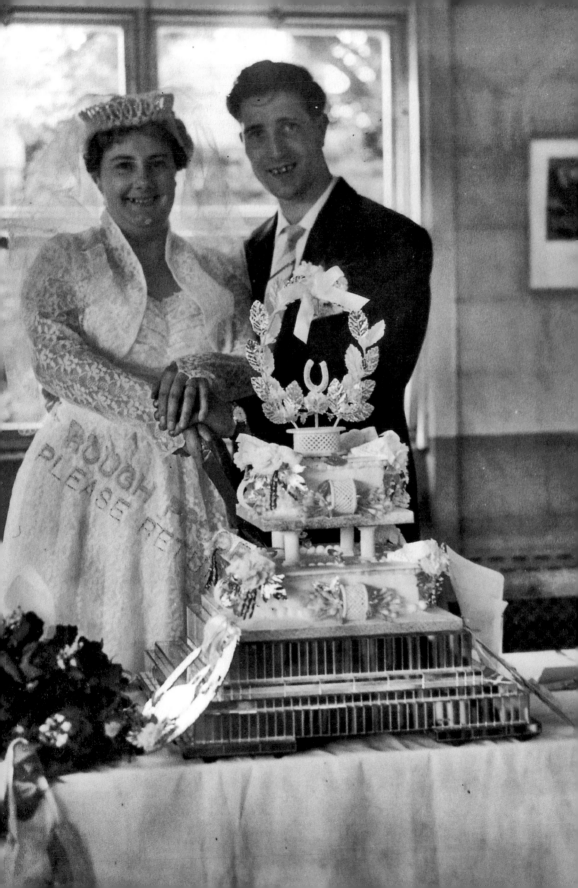

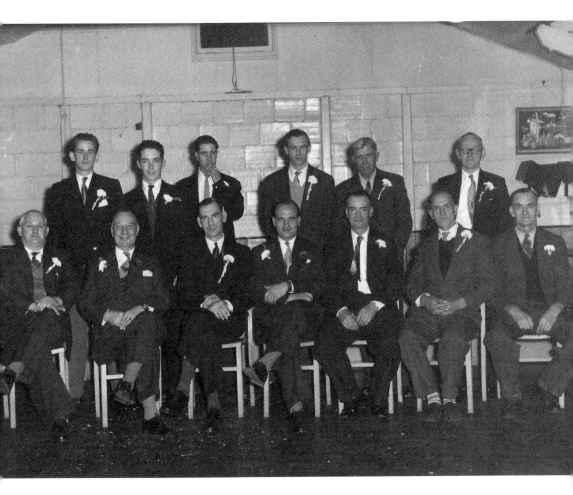

Opposite and above: Beryl and Bill's Wedding, 10 August 1957. William McAllister, Leonard Baker, Leslie Eales at Mr and Mrs McAllister's wedding day on 10 August 1957.

VE celebrations. After the Second World War ended, victory parties were thrown across the country.

3
Angela Hopkinson's Story

Angela Hopkinson, aged fifty-one, talks about living in the East End.

I've always lived in the East End of London. I originally come from East Ham. I moved to Canning Town when I was fourteen years old and I have been living here since.

When I was younger coming from East Ham was seen to be posh, as it was seen to be an affluent area back then. I feel that when I was growing up it was a lot safer, because you didn't often hear of stabbings, shootings or serious crimes, as there were no disagreements between neighbours; everyone helped each other. Plus, when I was growing up you had 'bobbies' walking the beat, but you don't see that often happening now.

I grew up on a prefab estate in East Ham, which is now known as Beckton. They were built immediately after the Second World War to house those left homeless after the war. All of the turnings on the prefab estate were named after well-known generals and war heroes, such as Eisenhower Drive, Montgomery Gardens, Tedder Gardens, Mallory Gardens, Bartram Gardens and Maitland Gardens.

I remember it was like a little village because we had our own fish and chip shop, butcher's, greengrocer's, off-licence, post office and a sweet shop. Eisenhower Drive, the road I lived in, had lots of mini-roundabouts with fancy chains around them and flowers planted in the middle. At the end of Eisenhower Drive they had a clubhouse that used to host functions such as New Year's Eve parties, dances, kids discos on particular evenings, darts games, and bingo. It was like a community centre. The clubhouse used to do day trips to the seaside, everyone from the estate used to attend the centre.

I remember when my mum went to bingo, she would bring back a bottle of strawberry cream soda pop, special cheese biscuits and Bovril crisps. My mum used to work in a local sweet factory that made coconut ice and peanut brittle.

Furthermore, at the other end of the main road they had a slaughterhouse called Ziff Meats, and on hot days the smell was nauseating. Opposite the slaughterhouse there was a massive park, and when we were over there we used to find dead animal parts such as horns that the slaughterhouse had thrown over.

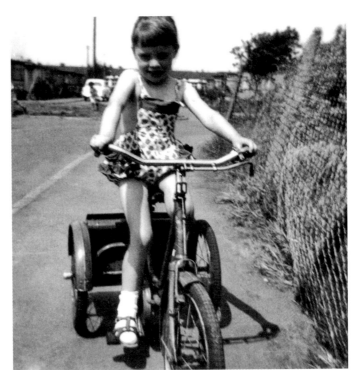

Angela, aged four years old, riding her bike along the prefab estate.

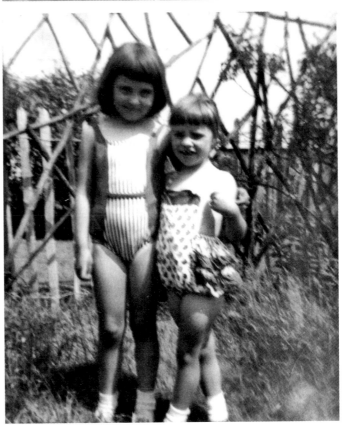

Angela aged one years old at her sister's fourth birthday party with Leonard and Grace Baker.

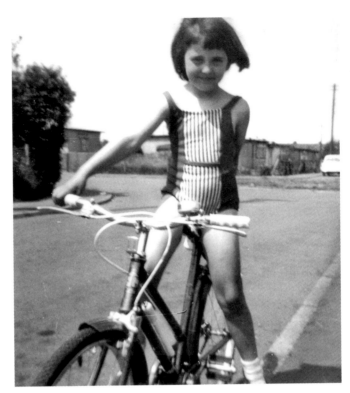

Right: Angela's sister.

Below: Angela aged
twenty-one years old.

When I was eleven years old, in 1976, we were forced to move out of the prefabs because they were knocking the estate down as it was built on marshland. Our family then moved into a townhouse in Plaistow.

Down Grange Road there used to be a club, like a working man's club, which used to host discos, dances and other functions similar to the clubhouse at the prefabs. When I was fourteen years old, my friends and I entered a raffle in the club and we ended up winning a bottle of Scotch. We drank it with our Coca-Cola and we all ended up crawling home as we were smashed and I have never touched Scotch since.

I remember one night my mum was out on a Christmas do and she returned home drunk. She lay on the sofa and kept singing 'Show Me the Way to go Home' at the top of her voice. I could hear my nan say, 'You should be ashamed of yourself, Beryl, coming home in that state!' While my dad was continuously laughing and my mum ended up rolling off the sofa and onto the floor.

When I left school, I started working for the Co-op as a chief cashier, but I was made redundant after a year because they closed our shop down. After working at the Co-op, I then started working for Barbican policies at Lloyds as a filing clerk. I worked my way up and met my best friend Larraine. As a teenager I used to attend the Lyceum with my friends, but with Larraine we used to go to Mooro's, which was the pub Bobby Moore used to own, situated in Stratford. Sometimes we used to attend The Two Puddings in Stratford, but not that often because it wasn't that nice in there. We did like to venture outside of East London occasionally on nights out and used to visit places like the Ilford Palais, Epping Forest Country Club and Legends and Chains in Barking. Often we used to visit the Queen Vic in Albert Square, Stratford.

In East London, when I was growing up, you used to be able to go on a pub crawl as there used to be a pub on every corner. However, nowadays there are hardly any lively, decent pubs that still exist. The East End of London has seen a massive change over the last two decades.

However, after I got married, I moved to Canning Town and gave birth to my daughter in 1993. When my daughter was five years old, I thought she'd gone missing when she disappeared from the house into our neighbour's house without me knowing. I knocked at the neighbour's house, but I never got an answer so I thought she was out. I was running down the road looking for my daughter and all my neighbours and other locals were running around trying to help me find her. However, she came knocking on my door with my neighbour; it was then I realised what my mum and nan used to say about the East End neighbourhood. My mum and nan always used to tell me that the people who live and come from the East End of London were the salt of the earth 'diamonds', meaning they were good people and they would do anything for anyone that needed help. The old East End community is like having a very large second family.

Angela, aged four years, visiting her grandparents in 1966.

4
East End Pub Culture

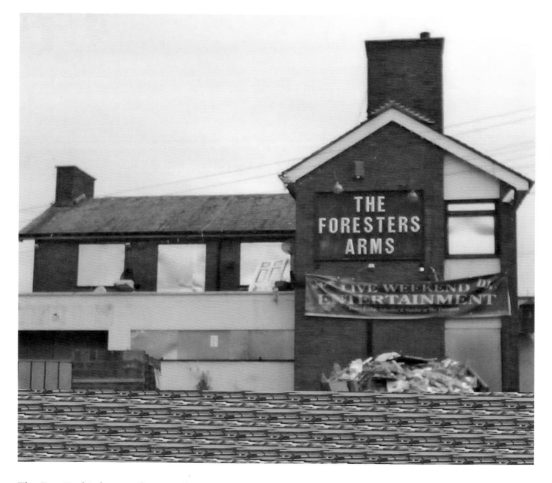

The East End is known for its pub culture. However, as the years have gone on, this culture has sadly begun to die out. The local pubs are shutting down one after the other, either as a result of the recession or a lack of customers. Pictured above is the Foresters Arms, Plaistow, 2012.

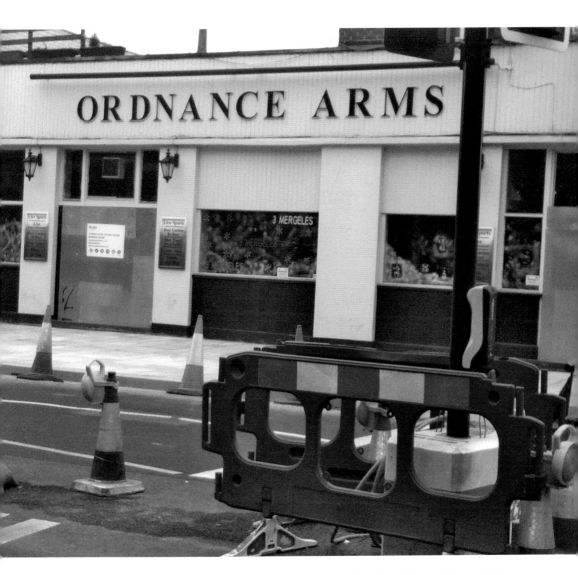

The Ordnance Arms, Canning Town, 2012. East End pub culture has changed dramatically in recent times. Every weekend, especially on Sundays, people would put on their Sunday best and go up to the pub. Since the advent of television and social media, people have stopped visiting the pubs in their droves, not just in the East End but nationwide. I remember my grandfather used to drink in the Dartmouth Arms in Canning Town and then in the glory at the Abbey Arms. The men would stand on one side of the pub and the women and children would be standing on the other side

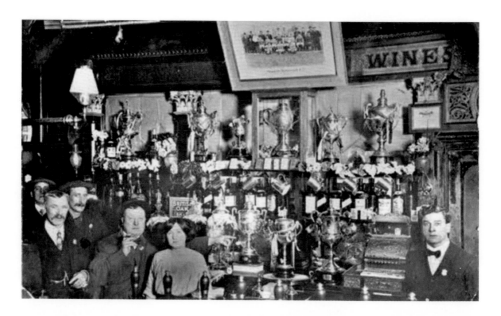

The framed picture over the bar is titled 'Vicar of Wakefield FC, 1911–12'. The following information has been supplied by Daron Humphreys. The picture was taken in 1913. The young lady is my great-grandmother's sister, Dolly Cooper, the man behind her is my great-great-grandfather, Arthur Cooper, and his son Len is standing on the far right of the picture. Arthur Cooper also ran a fleet of Hackney cabs from No. 64 Three Colts Lane and was also a horse slaughterer at the same address. A photograph of the pub's football team in seen below, taken in 1911. The top row, from left to right, are: Henry George Maffia, Mr Oakman (VP), Mr Cunnew (VP), Mr Gullen (VP), Mr Len Cooper (VP) and also pub landlord. Bottom row, from left to right: Mr James kneeling (Trainer), Mr McGee (Player), Mr Keller (player), Mr Sawyer (Captain), and Mr Crew (Committee Member). (*Courtesy of Phil Mernick*)

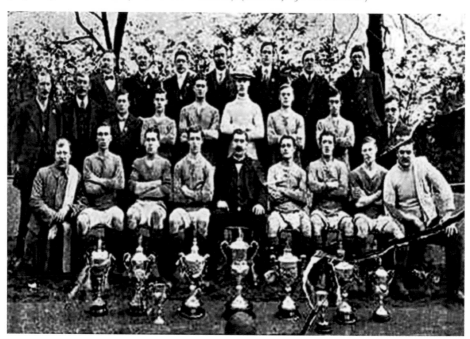

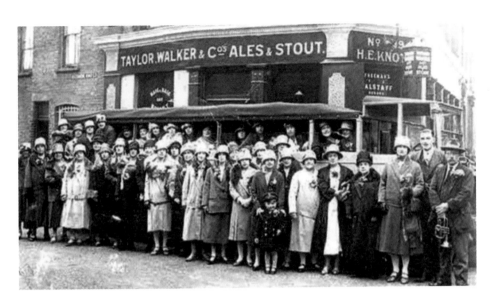

Outside the Lord Raglan, No. 19 St Ann's Road. A photograph by A. Griffith & Son of Armagh Road, Bow, in around 1900. Where is the group going to? Is it a wedding party? There are no women, but some of the men have flowers on their coats. There is a curious mixture of formal and informal, and there is obviously going to be music. St Ann's Road came off Burdette Road and has now completely vanished under Mile End Park. Curiously it is described as being in the Bow Common district in the 1902 Post Office Directory. (*Courtesy of Phil Mernick*)

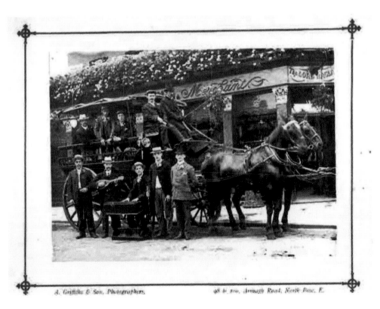

Preparing for an outing. A party of ladies pose outside the Earl of Ellesmere public house in the late 1920s. Horace Ernest Knott is listed as publican of the Earl of Ellesmere, No. 19 Chisenhale Road, Bow, from 1928. He had moved to another local pub by 1934. Everyone is wearing a corsage. Note, there are only two men in this party. One is a musician, the other is, possibly, the charabanc driver. (*Courtesy of Phil Mernick*)

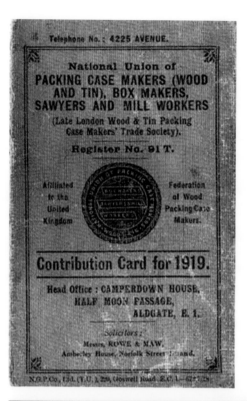

A 1919 union card for the National Union of Packing Case Makers (Wood and Tin), Box Makers, Sawyers and Mill Workers. The manufacture of wooden cases was once an important local industry. The back of the card shows that branch meetings were usually held in pubs. (*Courtesy of Phil Mernick*)

LIST OF BRANCHES.

CENTRAL BRANCH.
"Barley Mow," Errol Street, St. Luke's, E.C. 1.
TUESDAYS AT 6.30.

POPLAR BRANCH.
"Duke of Suffolk," Suffolk Street, Upper North Street, Poplar, E. 14.
MONDAYS AT 8.

BROMLEY BRANCH.
"Cherry Tree," Brunswick Road, Bromley-by-Bow, E. 3.
MONDAYS AT 8.

HACKNEY WICK BRANCH.
"Victoria Tavern," Wick Road, E. 9.
MONDAYS AT 8.

KINGSLAND BRANCH.
"Old Basing House," Kingsland Road.
WEDNESDAYS AT 7.

MILE END BRANCH.
"Crystal Tavern," Burdett Road, E.
TUESDAYS AT 8.

BETHNAL GREEN BRANCH.
"Good Intent," Mowlem Street, Cambridge Heath, E. 2.
FRIDAYS AT 8.

LIST OF BRANCHES.—continued.

DEPTFORD BRANCH.
North Camberwell Progressive Club, St. James's Road (near Canal Bridge), Old Kent Road, S.E. 15.
TUESDAYS AT 7.30.

WEST HAM BRANCH.
"The Royal Oak," Barking Road, Canning Town, E.
MONDAYS AT 7.

WALTHAMSTOW BRANCH.
Walthamstow Trades and Labour Council Hall, 34, Hoe Street, Walthamstow, E. 17.
WEDNESDAYS AT 8.

BATTERSEA BRANCH.
"Duke of Wellington," Meyrick Road, Battersea, S.W. 11.
TUESDAYS AT 7.30.

NORTHAMPTON BRANCH.
Trades Club, Overstone Road, Upton.

The Anchor pub was the local pub on Star Lane, situated at No. 20. The Anchor was present during 1902 and was rebuilt by the Courage Brewery in 1904. However, because of redevelopment during the 1970s the pub became secluded and lost all of its surrounding neighbours. The Anchor used to be a lively and busy pub full of locals. In 1999, there was a revenge attack on the landlord of the pub – teenage stupidity. It closed in 2001 after a somewhat horrific murder in the pool room. The pub was gutted by fire, and nothing constructive has happened to the building since.

5
Docklands

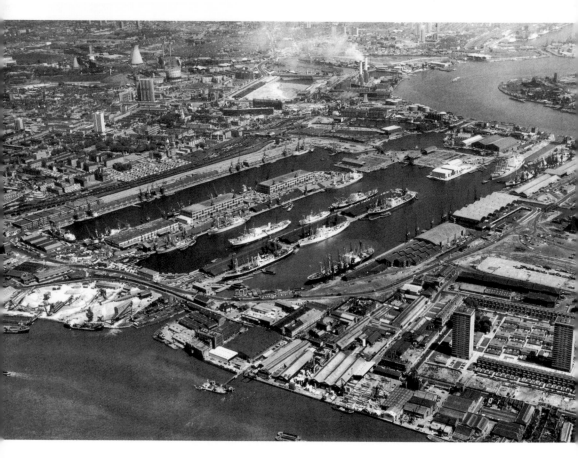

The history of London's docks is a story of obsolescence. The docks became obsolete almost as soon as they were dug, unable to cope with the ever larger ships made possible by the age of steam. By contrast, the Royal Docks were at the forefront of technology for a good many years, and they enjoyed a period of great prosperity, before their end came suddenly in 1981. (*Courtesy of Tom Samson*)

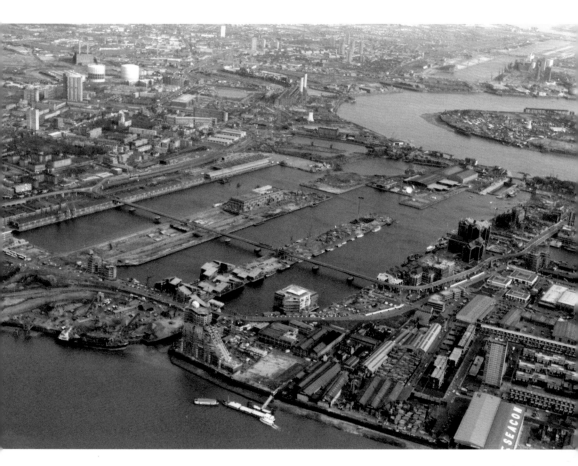

Docklands today. (*Courtesy of Tom Samson*)

Royal Victoria Dock, the first of the Royals group, was opened by Prince Albert during the Crimean War in 1855. It incorporated a whole range of firsts: it was the first dock to use the new railways, the first designed to take the new iron steamships, and the first to use hydraulic cranes and lifts to raise ships in a pontoon dock. Its success led to an extension to the east and the construction of the Royal Albert Dock, which opened in 1880. Finally came King George V Dock, begun in 1912 and, after delays caused by the First World War, opened in 1921. Marshland to the north, which is now Beckton, was earmarked for further expansion of the dock system. The Royal Victoria and Royal Albert Docks handled bulk grain. As refrigeration methods improved, they started handling frozen meat, fruit and vegetables. During the 1926 General Strike, some 750,000 frozen carcasses in the Royals nearly rotted when electrical power was cut off, but two Royal Navy submarines sailed in to save the Royals' bacon by connecting up their generators to keep the freezers going. Passenger cargoes also became big business. King George V Dock could berth the biggest liners of the time. Passengers could travel from main line London stations by rail, some staying overnight in the now Grade II listed Gallions Hotel. By the 1970s, features that had made the Royals ultra-modern in their heyday were militating against them. For example,

cargo operators preferred ports with good road connections, which the Royals lacked, while passengers unsurprisingly preferred the speed of air travel to that of the sea. The Royal Docks were still open when the London Docklands Development Corporation (LDDC) was set up in 1981, but the Port of London Authority closed them in December of that year.

Memories from the Docklands
(Courtesy of the London Docklands Museum)

Do you think the dockers supported the strike of 1926?

You only have to ask my manager. They reported no apparent dissatisfaction with work or wages, not on the part of regular parties; in fact, I have it on good authority many came on strike with the greatest reluctance, solely due to intimidation. The marches we saw contained only a small proportion of real dockers among them, most people were the 'riff raff' of the East End. During the entire progress of the strike, the dock director's joint committee were offered the services of a considerable body of men, yet as a result of threats and physical violence they were forced to turn back at our gates, and they called these brave men 'black legs'.

The London Docklands Development Corporation

For nearly seventeen years, between July 1981 and March 1998, the London Docklands Development Corporation (LDDC) worked to secure the regeneration of the London Docklands, an area of 8½ square miles stretching across parts of the East End boroughs of Southwark, Tower Hamlets and Newham.

Dock Coopers

Dock coopers could increase their income by working extra hours in private. The docks were very strict; they were built to stop pilfering, but of course some of those casks in the warehouse leaked, aided by the men working there. Those that were caught could have lost their position and their good name.

Working in the London cooperages was hard. The great West India Docks opened with a warehouse full of barrels of sugar and rum. Workers were often required to check the tightness of wine and spirit casks against leakage. The hours were shorter and regular.

Making casks for the Army or filling old ships could earn you an extra six or ten shillings a week on top of the regular wage of one pound eleven and sixpence.

In 1832, the Dock Company began dismissing their servants. The principal officer would ask how many children they had, and if they were employed. Those dismissed due to downsizing were given an allowance of £30 a year, but it was nothing compared to the usual allowance of £105 a year.

6
Stratford

Stratford is part of the London Borough of Newham in the north district of West Ham. Historically, Stratford was an agrarian settlement in the ancient parish of West Ham, which transformed into an industrial suburb. Stratford increased in population with the regeneration linked to the Olympics in 2012.

Travel has also been improved to make it easier for the locals and tourists to get around with the building of Stratford International station. Stratford DLR station has been built to serve the whole of East London.

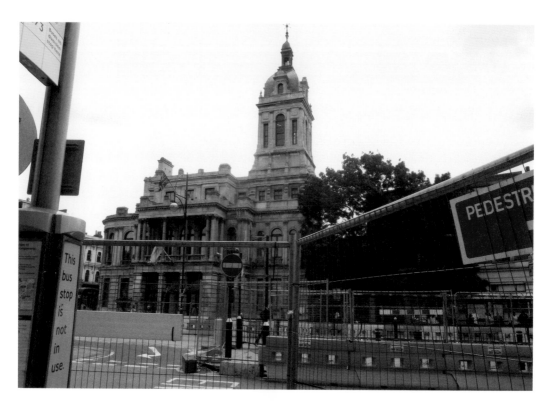

Old Stratford town hall today. (*Courtesy of Michael Foley*)

7

Tracey Hart's Story

Tracey Hart was born and bred in Plaistow.

I used to go to Gainsborough Primary School, but unfortunately I was bullied throughout the time I was there. As you can understand, my parents didn't want me going to the link school, which in this case was Eastlea Community School, due to the bullies going there.

I then began my secondary education at Plashet Girl's School in East Ham because my aunt used to go there; unfortunately, due to being bullied, my confidence was very low so I found it very hard to make friends. I thought of every excuse in the book to get out of going to school: my uniform was dirty, it's teacher training, and so on. However, my favourite excuse was to walk through the memorial park as if I was heading to the train station, turn around, go back home and tell my mum that I missed my train! This went on for a while, about four months, and then I got a transfer to Little Ilford School, which my cousins and brother all attended.

I gained a bit more confidence as my brother was in the same year as me (my birthday is in September and his birthday is in July so we always stayed in the same year). At least I knew someone here so I didn't have to walk around a playground not talking to anyone. I started to muck about in class; I also began fighting with my brother. For years I had been bullied but now I felt I was beginning to fight back, except it was with my family rather than the bullies!

I soon stopped going to Little Ilford and used the same excuse as before. My mum never said anything but I could tell my dad was getting annoyed with it. Soon, I didn't even bother getting out of bed. This went on for months until one day the Education Welfare Office (EWO) came to visit. The education welfare officer was a rather large lady named Mrs Blackman. I tried the same excuses on her but they obviously didn't work! One day I told her I never had any clothes, the next visit she gave me a black bag filled to the brim with clothes! There were colourful blouses, long, flowing skirts and

even a variety of T-shirts. Now this would have been gratefully received if a) I actually needed the clothes, b) the clothes were trendy to a fourteen-year-old girl, and most importantly, c) I wasn't a size twenty as she was, I was a size six! I give Mrs Blackman her due; she tried very hard to get me to school but to no avail.

The fighting got worse at home and then one day came the news I thought would never actually come. The education department was going to take my parents to court for not making my brother and me go to school. I was mortified! I never wanted to get my parents in trouble. They couldn't afford to pay the £1,000 fine that was being threatened! I thought about what I had to do and decided I was going to put myself into care. I'd heard of a children's home called Redstone Lodge in Manor Park, just opposite Wanstead Flats. They had a school on site and also sent you to mainstream school for English and Maths lessons. I told my parents what I wanted to do, and although they weren't pleased, I stood my ground and explained that I would be home for the weekends and holidays and I would visit two nights in the week. So it was that in June 1988 I was put into care under the supervision of the local authority.

When I first went to the children's home I was really nervous. I was given my own room, which had a sink in it. It was very comfortable but it smelt sterile as if the cleaner had gone round everywhere with a bottle of Dettol. The place itself was two houses that had been knocked together to make one huge house. As you walked through the street door you had the office to the left for the care workers, the front room (or the TV room as we called it) was to the right, and further down past the staircase was the entrance to the dining room. This had a door leading to the kitchen and another door leading into what would be the house next door. This room was the pool table room. The classrooms led off the pool room. I was then shown the laundry room where we had to do our own washing; this was completely new to me as my mum used to do all of that! We also had to cook our own evening meals, do our own ironing and make our own beds. We had a cook during the day who would cook lunch, as we were still at school. I was told that bedtime was 10 p.m. and no boys were allowed in the girl's room or vice versa.

All these rules were new to me, and by now I had butterflies in my tummy! I was even more nervous the next day when I had to go downstairs to school! I felt sick. I hadn't been to school for months and wasn't sure how I was going to get on. There were two classes with around seven kids in each class. The teachers were called Tony and Cathy; I had Cathy, although everyone agreed that Tony was the better teacher. He was more down to earth and in tune with the teens in the home. The care workers were really nice too.

The head care worker was called Margaret; I had a huge row with her one evening after throwing an ashtray and getting into a verbal fight, which ended in me swearing at Margaret! I got excluded for one evening and had to apologise the next day. There was this one lady, Emily, who had a dog and she always used to bring him in. She took some of the kids out one night and one of the lads had a drink without her knowing. When they came back he tried to jump from his window to the window next to his where some girls were sleeping. Stephen ended up missing the ledge, falling and breaking his leg. As you can imagine, all the kids were up in arms over this! How dare an adult not look after us properly! She never got the sack but we all ended up

disliking her! Looking back now, we were very foolish to try to blame someone else for our mistake.

Time in the children's home passed quickly and I have to admit that those couple of years were some of the best years of my life. I started to attend Forest Gate Secondary School for Maths and English, and even sat two GCSEs. We would walk across the field to go back to Redstone Lodge after lessons had finished and the cows would wander from the flats into the front garden and we would sit over the flats just chilling. The house is still there, although it's now back as two residential properties. I often wonder what happened to everyone.

I still keep in contact with a few people thanks to Facebook. Do I ever regret not going to mainstream school full time? Yes, although I wouldn't have met some amazing people. However, I would have more GCSEs and maybe the career I always dreamed of. Do I ever regret going into care? No, it taught me to face up to my responsibilities, be self-reliant, taught me life and social skills, and gave me some wonderful memories. I do, however, regret not speaking more to my dad about my decision to go into care. After my dad died, I found out from my aunt, who didn't know I had gone into care, that it must have really upset my dad when I went into care as he tried so hard to keep me out of care when I was a baby. I just hope my dad understood my reasons behind the choice I made. I still live in Plaistow and I work in a primary school, mainly with children with behavioural needs. I feel it's my time to give back and I come down like a ton of bricks on anyone I hear that is bullying others! I do believe that bullying led to my life in care and it has scared me but I love my job, my kids and my life, and I feel that living in the children's home has made me the strong, independent woman I am today.

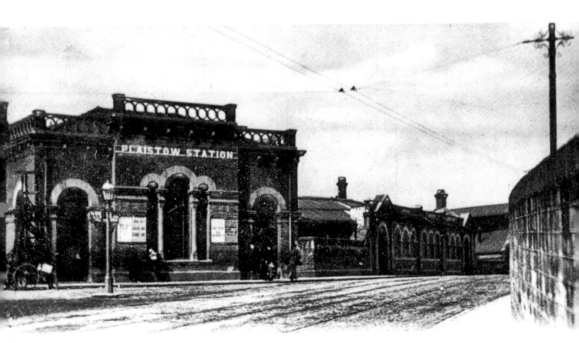

Plaistow station. (*Courtesy of Michael Foley*)

8
Roy & Beryl Worboyes' Story

Roy David Worboyes and Beryl Winifred Cave got married when they were only just eighteen and sixteen years old.

Roy David Worboyes and Beryl Winifred Cave met in a hospital while Roy was visiting Fred, Beryl's dad. A few weeks later, Beryl and Roy started courting. When Roy was eighteen years old and Beryl was only just sixteen years old they made the life changing decision to get married. On 19 December 1964, at St Luke's church, Roy and Beryl exchanged vows and became husband and wife.

They went on to have five beautiful children, one boy and four girls. In 1972, they moved to Fisher Street, and to this day Roy still lives there. In 1982, Beryl, who was just thirty-three years old, lost her fight with cancer, devastating her family. Roy then had to bring up the children by himself, the youngest just being four years old.

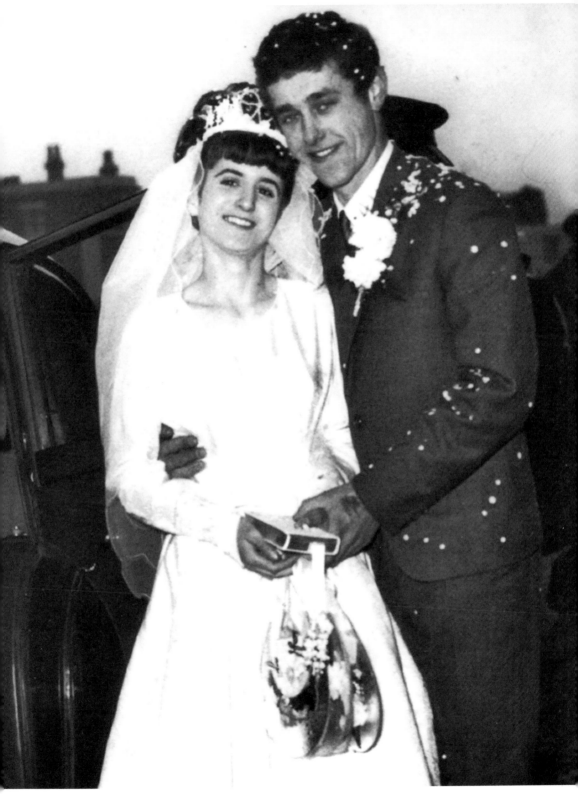

Mr and Mrs Roy Worboyes on their wedding day on 19 December 1964 at St Luke's church.

9
Pat Hart's Story

Pat Hart has lived in Canning Town since she was born.

I have lived in Canning Town since my birth; I lived in Malmesbury Road, which is where Manor Road is now.

The Canning Town roundabout used to be a crossroad with Barking Road, Liverpool Road, Silvertown Way and East India Dock Road. Where Canning Town station is now used to be the Liverpool Arms public house. Then it was the Imperial Cinema (locals called it the flea pit) and there was also a big hotel that used to be situated next to it but I can't remember the name.

Canning Town station itself used to be on the site where the MFI building is now, and next to that was a coal yard and a scrapyard.

On the other side of the post office was a shop called the Army & Navy, which was a big industrial clothing shop. Alongside that was a massive area where people who had anything to sell used to put an old sheet or blanket down and put all their unwanted items on there for selling – things like clothes, prams, bikes, anything would be there. It was a bit nasty at times, especially when it had been raining. You got covered in mud, nearly up to your knees if you were a child.

Further along was Rathbone Street where stallholders of all sorts used to sell everything from new or second-hand clothing to curtains and chickens, dead and alive, as well as eggs, and other meat stuff.

There was Olly's pie mash shop where every Canning Towner would go on a Saturday. And a Sarsparella drink stall selling hot drinks, yummy.

In the 1960s, things began to change. 'Old Rathy' had been demolished and a new housing estate was built there. Rathbone Market was newly built in Barking Road and was full of modern shops, bakers, butchers, clothes shops, which were all opened by television stars like Hughie Green, Bernard Bresslaw, David Kossoff and Bernie Winters.

Best of all were the stalls, which went from one end to the other on each side of the road. Every Saturday was like a day out and you could spend hours down there.

On the other side of Barking Road was an ice cream shop called Murkoffs, and everyone knew they had to get an ice cream from there. Sadly they shut down in the eighties. My very own three children and the two children I was a child minder to were lucky enough to have a cornet from there whenever we went shopping down Raffy. Yum yum.

Further along you had all sorts of small shops, and a large, old-fashioned Woolworths, where I got my first job on leaving school. The counters were highly polished wood and it was part of my job to clean the counter down with vinegar water, then polish it. It was such a messy job doing it that they changed all the counters so no one had to polish them anymore. I had left by then.

On the corner of what is now Beckton Road, where McDonald's is, there used to be a tobacco-cigar factory, which used to make the whole area smell of tobacco. Opposite that used to be a church (Trinity church) that was badly damaged in the war and was falling down, which was where the bus stop is now. Hermit Road used to have trams turning into it, and the trolley conductor had to jump off the tram and, with a hooked pole, change the cable so that it could go round the corner. The tram number was 669, our present-day 69 bus.

What is now the large betting shop used to be London Electricity Shop, where you were able to buy lightbulbs and when they blew out you could take them back and they would replace them for you for free. You would not be able to do that now.

Coming back to the roundabout, there used to be a men's clothing shop called Granitters, which was a popular shop for all ages. Near the Old Town Hall, now Community Links, you were able to get baby milk and the best orange juice that anyone could have.

The Royal Oak, which is now a Cash Converter shop (Oak Crescent), used to be a boxing club upstairs. Frank Bruno used to train there in the 1980s and was often seen leaving there after training, skating along the road to the car park.

There have been a few stars who came from Canning Town area. Frank Lampard Senior used to live in Liverpool Road, opposite the old Anchor Pub, which is still there, although unfortunately now a derelict building. David Essex used to live in Avondale Court, Reg Varney from *On the Buses* used to live in Avondale Road, and Johnny Speight who wrote *Till Death Us Do Part* with Alf Garnett, all used to attend Star Lane Primary School. Frank Lampard was in my class; David Essex was in the year above of me.

There have been so many changes in Canning Town. I can remember the rag and bone man coming round the streets collecting any old clothes or crockery and paying silly money for them – maybe half a crown, which today's value would be about twelve pence. The seafood man with his handcart came every Sunday about one o'clock, selling cockles, shrimps, crabs and other seafood. The ice cream van came each night, and if you took a bowl out he would put lemon ice, which did have pieces of real lemon in, and vanilla ice cream in it for two shillings, which by today's value would be twenty pence.

The major change to Canning Town is Rathbone Market, which has started a big overhaul of the area: new shops, flats and offices. I still live in Canning Town; I got married in the 1960s and have three grown-up children who have had a great time growing up in this area, even though times were bit hard, and money was short. We all still remember the good old times of Canning Town.

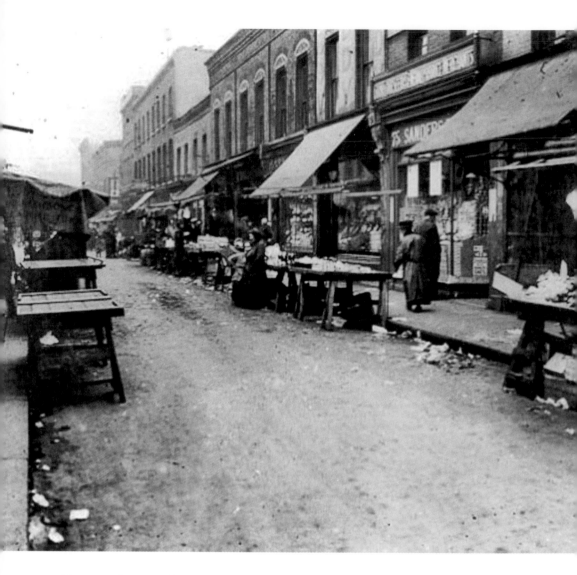

Rathbone Market is in the heart of Canning Town. It was once a thriving East End market, and has since been reinvigorated by English Cities Fund (ECF). Improvements hoped to bring 650 new homes to the area and approximately 35,000 square feet of new shops and cafés, wrapped around the new development of market square. Community facilities were also built, including a library, a new council office and a local service centre. Furthermore, environmental improvements were being made, which created attractive, landscaped, open spaces. Transportation services were included in the improvements from links to Canning Town station.

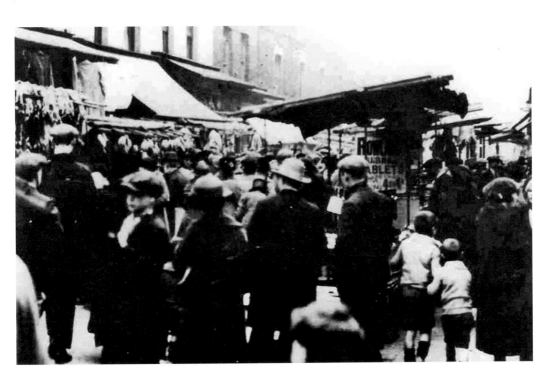

Rathbone Market, 1925 and 1947. Historic images of Rathbone Market over the last century. (*Courtesy of ECF*)

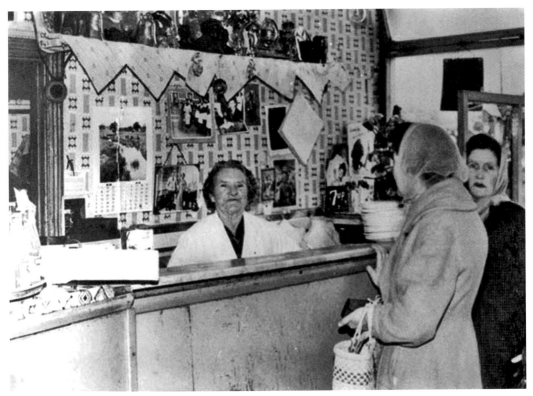

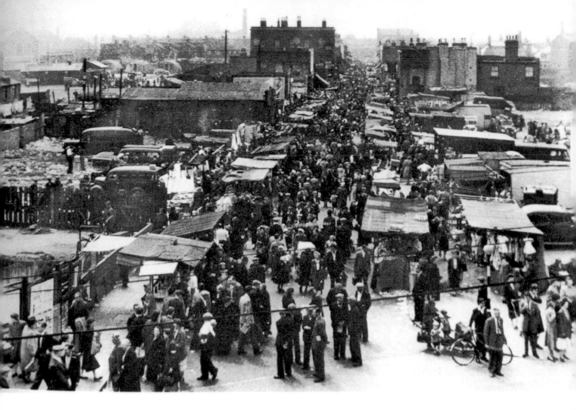

Rathbone Market, 1950.

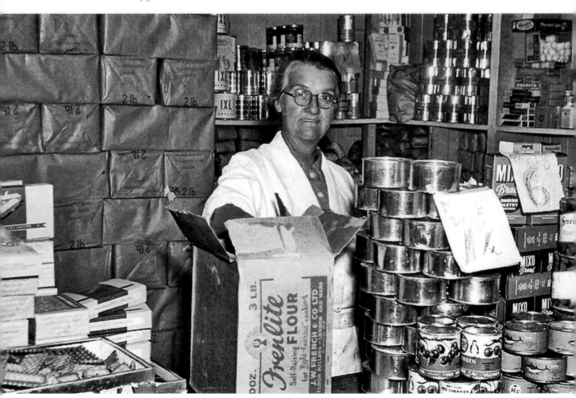

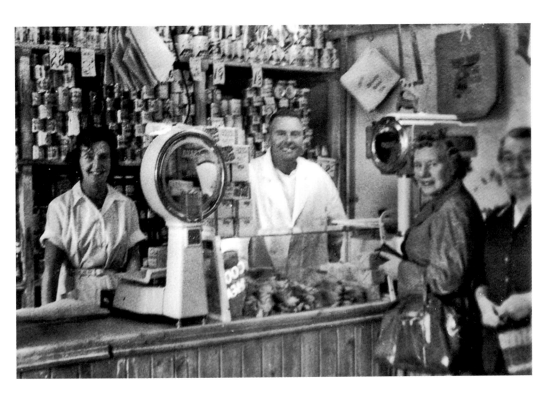

Rathbone Market, 1950 and 1959.

Left: Rathbone Market, 1959.

Below: Rathbone Market has been running for years; the market used to be so lively, packed with locals and stalls. Over the years, Rathbone Market has gone downhill. Stalls started disappearing, and trade has decreased due to the lack of stalls and stock. Pictured here is the Rathbone Building, officially completed in 2012.

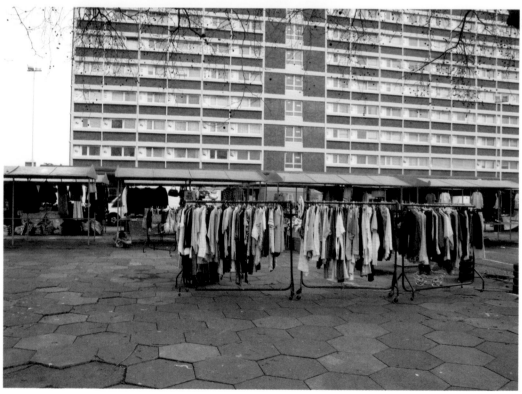

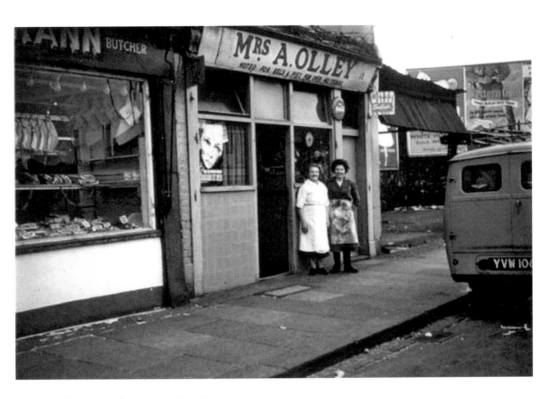

Rathbone Market, 1961 and 1964.

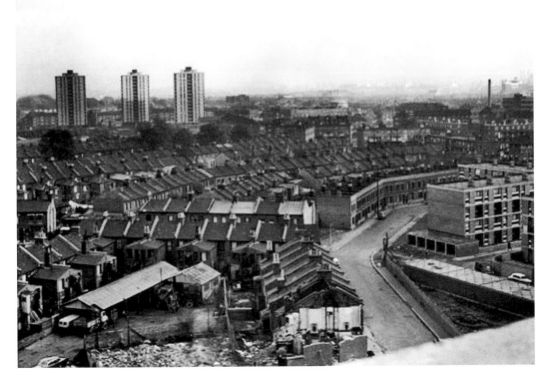

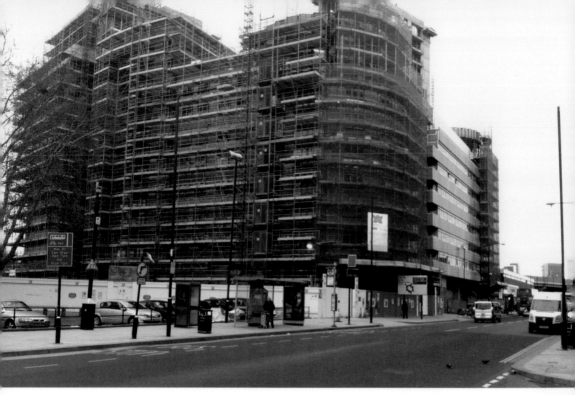

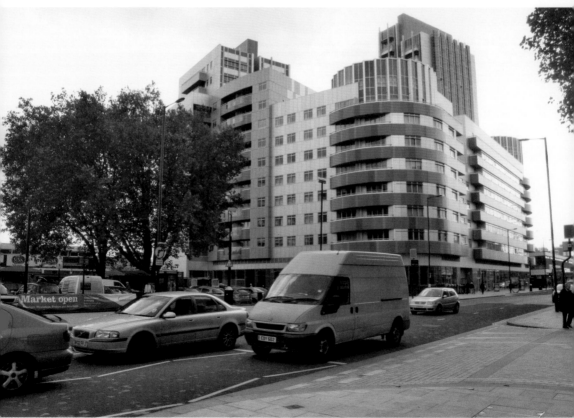

54

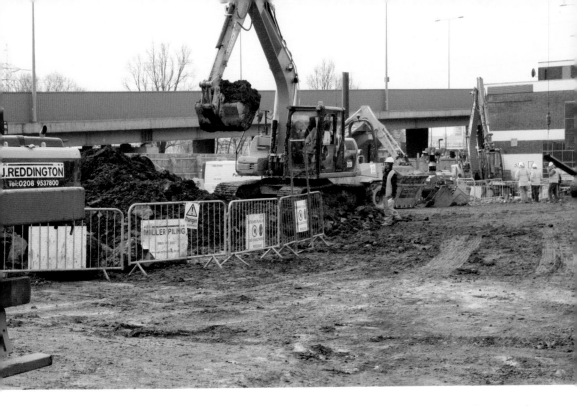

Opposite and this page: The Canning Town and Custom House regeneration plan saw the preparation of the site for the new Rathbone Market development – it was ready for the 2012 Olympics.

10

Mark Hopkinson's Story

My grandad Sid was a rag and bone man all his life.

From about the age of fifteen or sixteen years old, Sid had his own horse and cart, which he would drive around the streets of Barking, where he was born, calling 'Old rags, Rags Iron Lumber'. This meant he wanted old clothes, scrap metal, and timber to re-sell.

A couple of years later he married my nan, Rose, and they settled in Canning Town in East London. They went on to have six daughters, one of whom is my mum and one son.

Sometime later, he opened his own scrap metal yard in Hackney, but hankered after a more simple way of life, eventually selling up and going back to clearing scrap from his regular firms, replacing his horse and cart with a truck.

His main interest in life was his horses. Sid had the biggest stable in Cotters Yard, which was at the back of Wally Pope's bird feed shop. Currently this shop is known as BJS Pie Mash along the Barking Road, just before the Abbey Arms pub.

As a young man I worked for him for a short while. I remember my grandad feeding and grooming his horses alongside my uncle. His pals were mostly other rag and bone men and horse dealers. They were also known to be cleaning out their stables and shoeing horses, a way of life that belongs to a bygone age.

The stables that were at Cotters Yard are now overgrown and have become an unused piece of land. However, listen carefully and you might hear the horses' hooves on the straw-covered cobblestones, or the odd deal being done, and the voices of the men who used to stand there. Perhaps Jacko Harper and Hardie Mitchell shoeing the odd hoof, or Siddy Swan and Wally Nicholas talking horses on a sunny afternoon. They may be gone, but not forgotten.

As a boy I lived in my nan's house with my mum and sister, just off Dalston Lane in Hackney, 16A Myrtleberry Street. During the 1970s, it was a quite run-down working-class area. The houses where we lived were being bulldozed to make way for the 'new' Rhodes Estate that was being named after Cecil Rhodes, the founder of Rhodesia. He owned the original estate where we lived, before the Greater London Council (GLC) bought everything up.

For a couple of years, there was only our house left and Mrs Hammond next door. The rest of the street was flattened. So my sister Michelle and I pulled all of the fences down and had the whole street and the street behind us as our garden.

During the summer, the garden was overgrown with blackberry brambles and wild apple trees. It was our jungle. As kids we used to spend hours picking blackberries and apples with our nan, Lucy, who used to famously make us blackberry and apple pie.

We always had our Alsatian dog, Sheba, with us. Sheba was not the only pet we used to own; we had quite a few others from cats to rabbits, and a couple of chickens not to mention a tortoise or two. The local market was Ridley Road, a really lively and vibrant place to visit. There was a mixture of Jewish, Turkish and West Indian stallholders who used to represent the varying waves of immigrants over the years.

As a youngster I used to go there most days with my nan to do some shopping. Afterwards she would always take me for pie and mash at Cookes in Kingsland Road. They used to keep live eels in the front window back then in stainless steel trays with big blocks of ice, fresh for eating. About half a mile further along the Kingsland Road, heading towards Shoreditch, was another smaller market, but this market was not as busy as Ridley Road.

On really hot summer days my sister and I would head over to our local park, called London Fields in Richmond Road. This park used to have an open-air swimming pool, which has recently been refurbished. At the time my mum and dad were market traders but also had a shop along Valance Road in Bethnal Green. I have fond memories of my dad bringing back home bagels and chopped liver on a Friday evening to Myrtleberry Street.

11

Amy Elizabeth Ryan & Josie Brewers' Story

Amy Elizabeth Ryan was born on 26 July 1924. She worked for the American Red Cross during the Second World War, and sang to the troops. Josie Brewer (Amy Ryan's daughter) was born in Canning Town at 99 Malmesbury Road in 1947.

My mum was a famous singer around the East End of London, known as Bobby (Amy's singing name). Bobby sang frequently in all the local pubs such as The Ordnance and Royal Oak. None of these pubs are around today. I (Josie) used to work at Mayflower during 1979.

My parents moved to Woolwich when I was fourteen years old and I decided to stay in the East End of London with my nan. Sometimes for dinner I was made to eat beef fat, and to this day I can never eat it. While I was living with my nan, during the evening we used to get the piano out and have a singalong.

Meanwhile, after a short period of time, my parents moved back to the East End, and they lived in the upstairs of my nan's house while we lived downstairs. The toilet in my nan's house was in the garden or a bucket in the scullery. When my nan used to host a shindig (party) no one would drink any alcohol until she said. This was out of respect. My Uncle Jim was always known for farting!

My mum sadly died very young at the age of forty-nine years old. Aunt Violet and Uncle Jim planned the funeral alongside Cribs. My mum's funeral was the first funeral in the East End since the war to have a horse-drawn carriage. Thirty-eight years ago it cost us around £175 to import four chestnut horses over from Ireland, although customs would not allow them out of the boxes. The East End community contributed and paid for my mum's funeral, which took place on 5 November 1973.

Our family used to live on two streets. There was no Manor Road. It used to be Malmesbury to the end of Star Lane Road where the DLR station is, and the primary school as well as the Park all used to be houses and flats. West Ham dog track was situated off Three Masons Road, where the Greyhounds used to race.

My auntie used to live around Manor Road. Cranberry Lane used to be a coal yard, and all the kids used to lift the wire up to get buckets of coal. Years ago, kids used to live from one road to the other where their families were. The Landlord, Mr Senior, used to send Bill

Knight to collect the rent. Along Malmesbury Road a woman used to live a couple of doors away from us, and her dog Thomas used to nick the neighbours' meat. I remember we used to have a man come round the streets selling dairy products and we had a shellfish man.

When I was a little girl the Anchor Pub had Beanos. We did not go by coaches, we went by charabancs. Everyone went on the charabancs for a day trip to Southend, after all the kids used to go home. Next to the Anchor pub there used to be a fish shop called Hopkins. When the buses first came down the road, a bus went into the shop. Opposite the Anchor there used to be Bretts Shop, and next door to that was Liverpool Road, where Frank Lampard's nan used to live.

Over Star Park 'Green', where Avondale Courts used to be, were shops called Corks, Sub Post Office, Old Fashion Phone and Foxs Shop. Across the road was a butcher's. Nowadays you have to get a bus to get your groceries, but back then we relied on our corner shops.

Along Clarence Road there used to be a shop called Reynolds when I was ten years old. They had the first fizzy drinks machine as I remember, and we used to go down there with jam jars to fill up. Opposite there was Smiths & Taters Greens, as well as a potato shop.

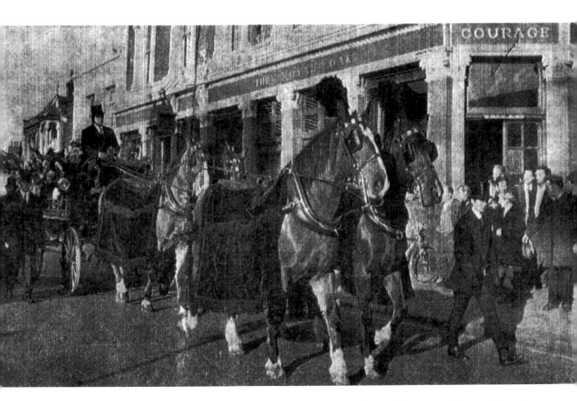

Amy Ryan's funeral, from an article that was published in the *Newham Recorder* on Thursday 8 November 1973. She was well known and well loved in the East End.

AMERICAN RED CROSS

IN GREAT BRITAIN

Telephone Number
Mayfair 7234

12, GROSVENOR SQUARE,
LONDON, W.1.

January 11, 1944.

Dear Bobby Ryan,

It is with the greatest regret that owing to necessar
economies in the American Red Cross in Great Britain this
department has been forced to give you two weeks' notice.
That your services have been appreciated I can assure you,
as witness to which I am quoting a letter I received from
Mr. Harvey Gibson, the Commissioner:-

"I am sure you appreciate my sincerity when I say that
no-one could possibly feel sadder at the necessity for
discontinuing some of our Entertainment Department activities
than I am. I have seen many of the performances and I
have been most impressed by the earnestness and unselfish-
ness of the various British members of your casts, to
nothing about their ity as artists. I woul
your expressing to them for me, my great regret that it is
not possible for them to be employed by the American Red
Cross for a longer period and at the same time express to
them my sincere thanks for their loyalty and unflagging
work for our organization."

To this I personally want to add my thanks. It has
ies you have worked under; mud, cold, rehearsals, illne
and all such things. I can only say you have behaved
like a "trouper", which is the best praise that I, of the
theatre, can give to an artist. God bless and good luck.

Sincerely yours,

Dwight Deere Wiman,
Director of Entertainment.

An Amy Ryan (Bobby) appreciation letter from the American Red Cross for her services during
the war as part of the entertainment team – Entertaining the Troops.

Above: Josie
Brewer in
Beckton.

Right: Josie
Brewer down
Liverpool Road,
Canning Town.

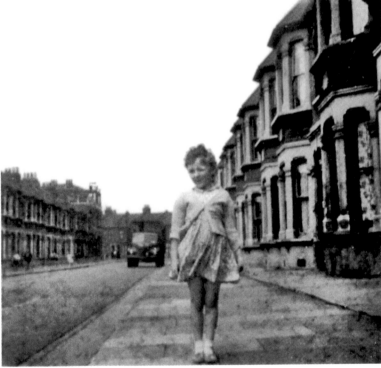

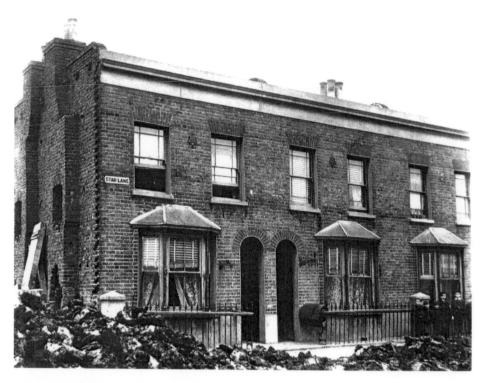

Star Lane Road, E16. (*Courtesy of Newham Archives*)

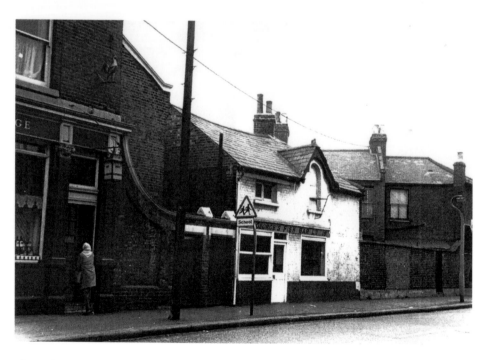

The pub next to George's fish bar, 18 Star Lane Road, E16, February 1973. (*Courtesy of Newham Archives*)

Byford Cottages, 231 Star Lane Road E16, 1883. (*Courtesy of Newham Archives*)

Grace Louisa Baker's Story

Grace Louisa Baker is the author's grandmother.

I remember I used to sit down with my mum and nan (Grace Baker) listening to their stories of the East End of London. When my mum was growing up my nan (maiden name Grace Louisa Howlett) had five brothers and one sister, whereas my grandad, Leonard Walter Baker, had three stepsisters and he was the only boy! My grandparents got married on Christmas Day at St Mary Magdalene church.

My nan came from the East End and my grandad was from South London. All of my nan's family used to live down the same street: Fabain Street, East Ham. I remember one story that my nan told me, which was during the war: my grandad was in the Army, based in Gibraltar, building the tunnels that run through the rock, which are still there today. Sometimes they used to take the railways down in the First and Second World War to make bombs.

When the sirens went off my nan would never go inside the air-raid shelter. She always stood in the garden. My nan had a nanny goat in her back garden and she used to tie it up against the sewer bank that used to run up against her back garden.

I remember visiting my nan and grandad's house when I was younger and their air-raid shelter was still based at the bottom of their garden. Inside my grandparents' house they had a large piano based in their living room, and on a Sunday afternoon my father (William McAllister) used to play it.

Once my grandfather left the Army he became a painter and decorator. I can remember my nan telling me that he had painted the Whispering Gallery in St Paul's Cathedral, and his name is displayed right at the top of the Whispering Gallery.

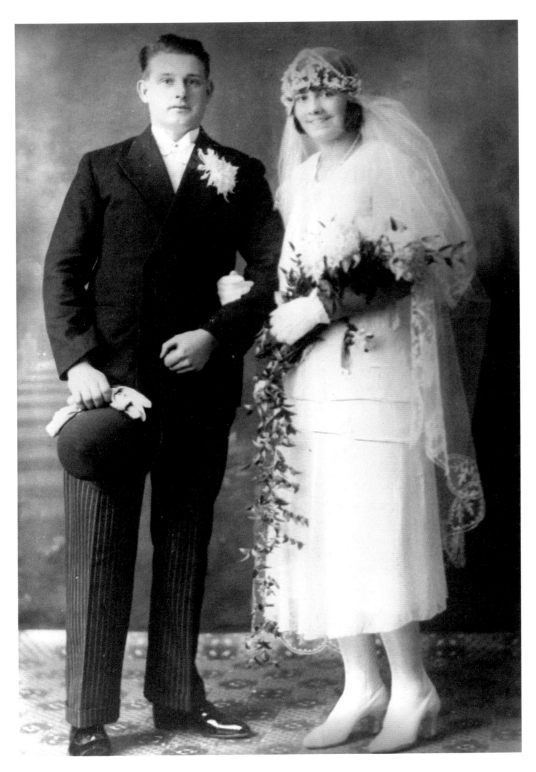

Grace Louisa Baker and Leonard Walter Baker on their wedding day, Christmas Day (25 December) 1929 at St Mary Magdalene church.

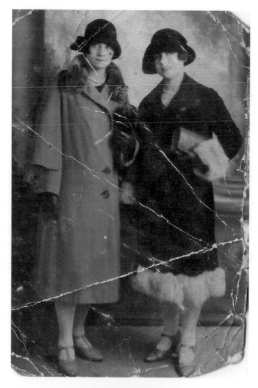

Grace Louisa Baker aged eighteen years old, beside her sister Emily, who was also known as Emmie.

Grace Louisa Baker, aged twenty-one years old.

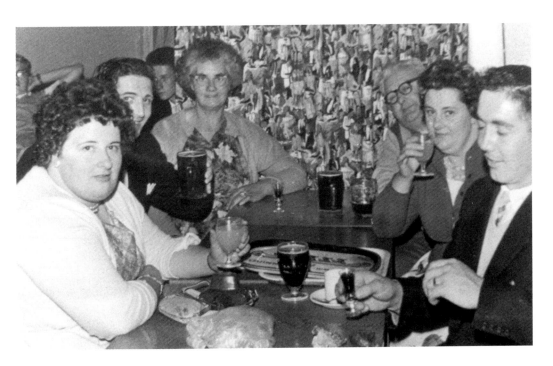

Grace Louisa Baker, Leonard Baker, Beryl McAllister, William McAllister, Rita Eales and Leslie Eales enjoying a good old drink on their holidays.

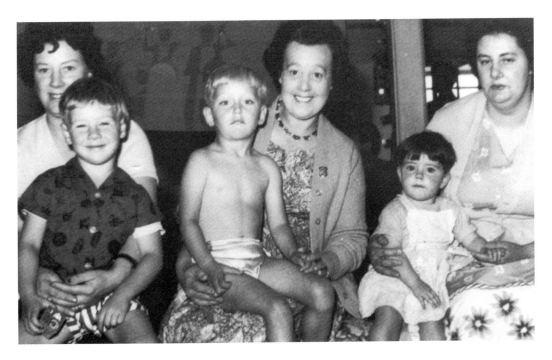

Beryl McAllister on the right-hand side, with her eldest daughter Wendy Smith alongside her cousins with their children.

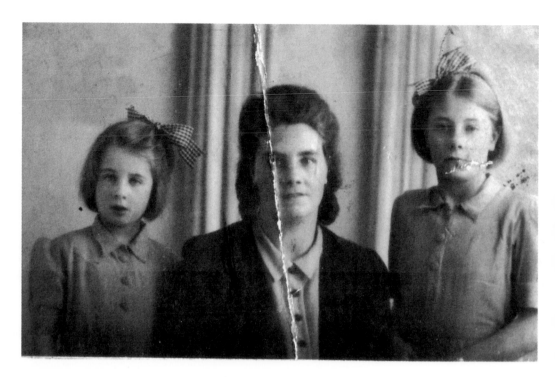

Grace Louisa Baker with her two daughters, Beryl McAllister, aged eleven, and Rita Eales, aged eight, going to a family party.

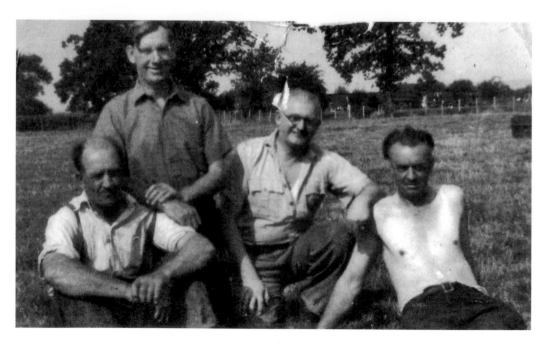

Leonard Baker with his brothers-in-law hopping down in Kent.

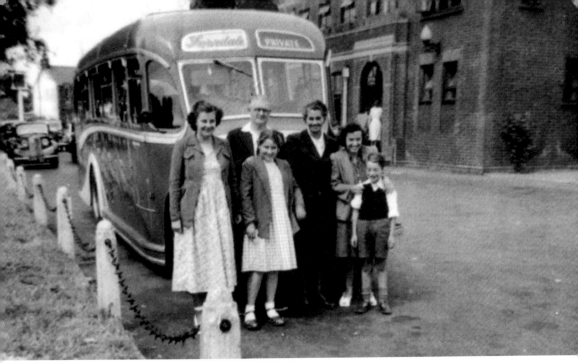

Above: Leonard Baker, Grace Louisa Baker, Beryl McAllister, Rita Eales and cousins on a day trip to Margate.

Right: Leonard Baker and a friend in Gilbraltar digging the underground tunnels during in the war.

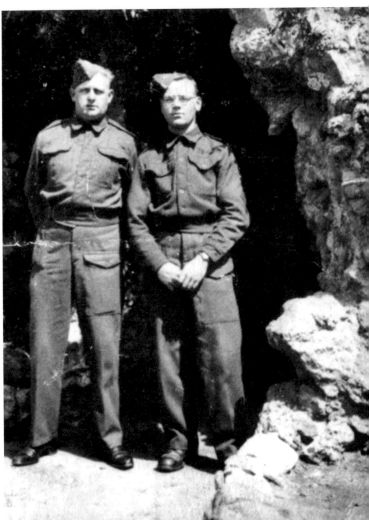

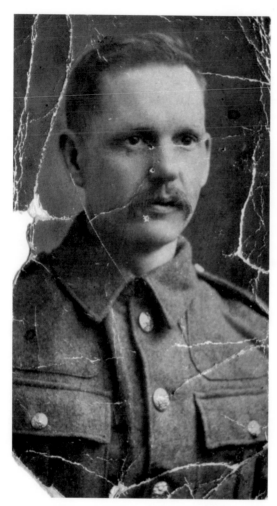

This page: Leonard Baker (*left*) and his Army battalion (*below*).

Opposite: All the names of the people in Leonard Baker's Army battalion.

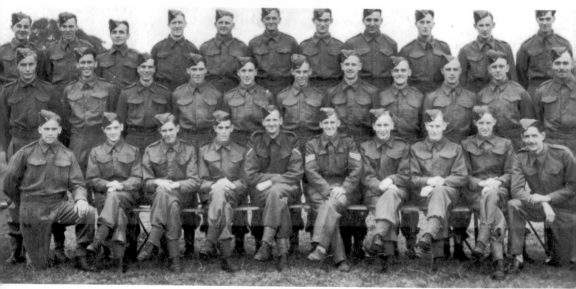

J. W. Wraxton Sgt Sept 6 19[?]

B. A. Winchester R. G. North

T. C. Thorpe W. A. Teight

J. C. Thomas E. H. Cooke

G. A. Wild E. Warburn

G. Raglen

a. Wilkinson

Steve Wall P. Mullineaux

G. Stanley Nash Ken Sproot

H. M O'Tians H. Windram

W Calves Denis McLaren Black

G. G. Rowett Thos. W. Wright

A. C. Wilson

A Will J E. Batty

P. Gibson

A. Green

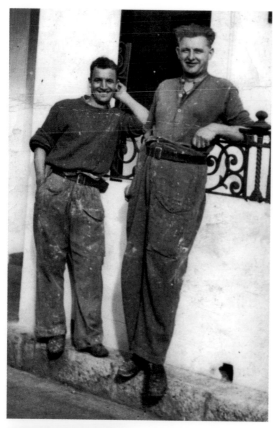

Left: Leonard Baker and his work colleague painting a house in London.

Below: The East End in the 1960s.

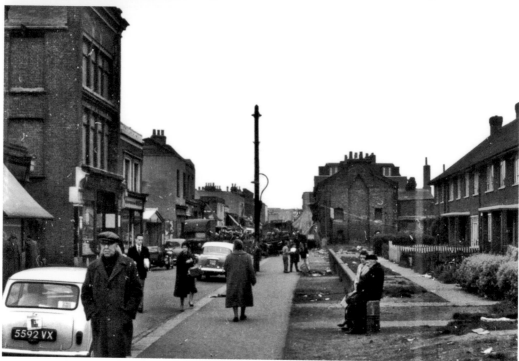

Right: A family portrait at the hopfields.

Below: A picture of the hop fields in Kent.

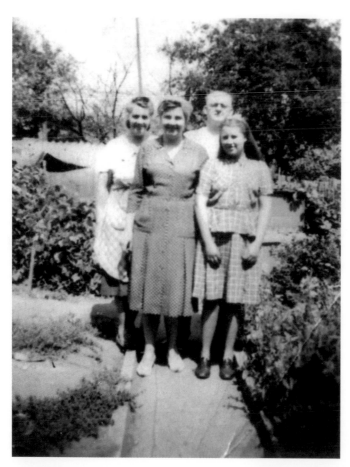

Left: Leonard Baker,
Grace Louisa Baker,
Beryl McAllister and
cousin at the hop fields.

Below: A wedding at
St Mary Magdalene
church in East Ham.

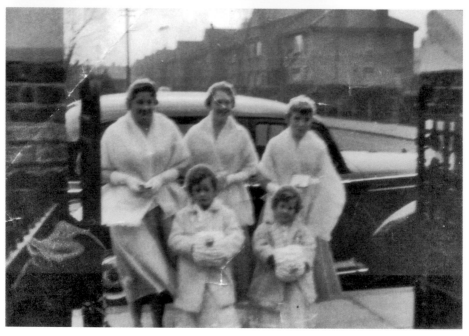

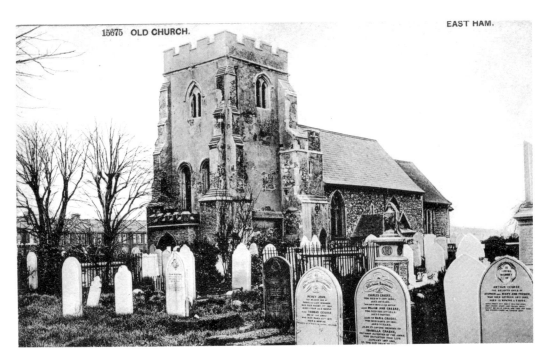

15675 OLD CHURCH.

St Mary Magdalene church, East Ham. (*Courtesy of Michael Foley*)

Left: My sister, Wendy Smith, aged two years old during 1961. Standing in my grandparents' garden, at the back of the photograph, is my nan, Grace Louisa Baker, and towards the back of the garden is where their air-raid shelter was situated.

Below: My sister Wendy Smith aged three years old (1962) sitting in my grandparents' front room attempting to play their piano.

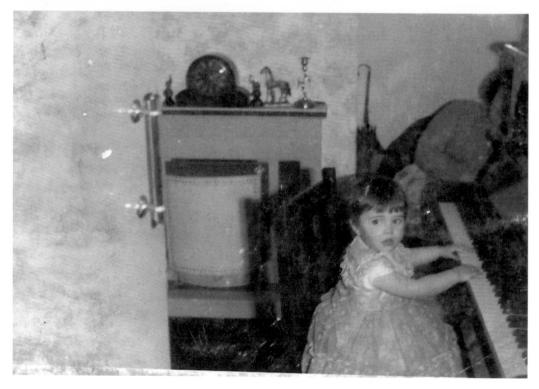

13
Michelia Brown's Story

Michelia Brown is a resident of Bethnal Green.

On 7 December 1936, at Bethnal Green hospital, my mum was born one of four children. My grandparents were Ethel Minnie Morgan, one of twelve children, and Henry Smith, who was one of fourteen children. They were one of the largest families within the East End of London. The family originated from Mape Street. Basically, my grandad's family were rag and bone men and years ago they used to be called 'Totters'. When they used to all go round with goldfish in the bowls like you saw in old films and they used to use the stables down on Seaford Street. As time went on my grandparents were one of the first families in the Bishop Bonner pub. So they were publicans, dressmakers and totters. They were one of those families that used to have their fingers in many pots.

My grandparents had four children: Ethel Smith, Henry Smith, Sylvie Smith and my mum Shirley Smith. Basically a normal East End family, I'd like to say. My uncle grew up in the Army. After five days he got thrown out and put in the glasshouse for fighting and thieving, as they all more or less used to do back then. The other boys in the Army were hungry so my uncle would break into the food storage so they could all eat. Basically all of my mum's brothers and sisters grew up around Bethnal Green.

All of the girls were machinists; years ago Bethnal Green had a large Jewish community there who were furriers down Petticoat Lane. My mum and her sister started off doing that and then started working for Jaeger as their top tailors. Their suits were first showcased on the models. As time went along my mum's sisters moved out and my mum met my dad at Ronnie Scotts in the West End. He was a foreigner – Italian in fact – and she ran away from him three times but eventually she did jump on the No. 6 bus to come home and used to wave at him through the window. My mum was not a prude as such but she was very reserved about being a woman in all honesty. My dad continued to pursue her and eventually my parents got married in Lady of Assumption church on 4 July.

Michelia aged around four years old, having her portrait photograph taken.

Michelia's mum, Shirley, around the same age, having her portrait photograph taken.

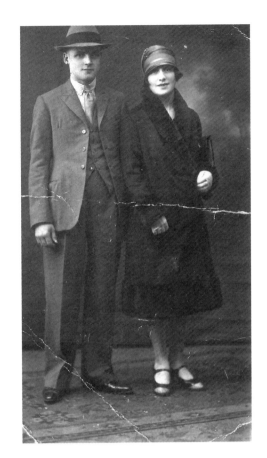

Right: Michelia's grandparents, Henry and Ethel Smith.

Below: Michelia's family day trip out to Southend seaside.

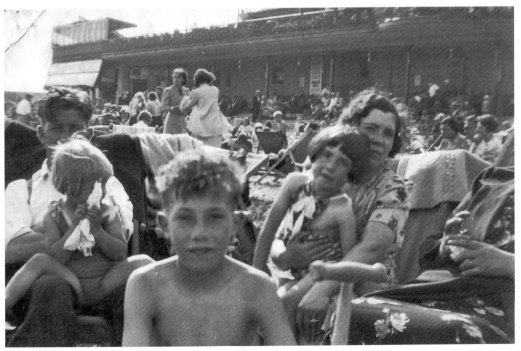

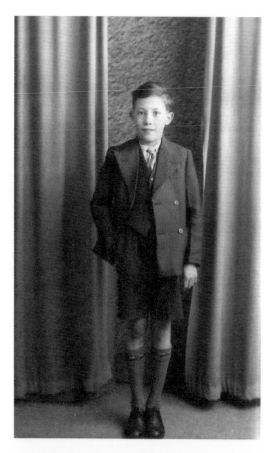

Left: Henry Smith as a little boy, Michelia's uncle.

Below: Henry Smith's medical card. You had to have one of these to get free medical treatment when there were charges.

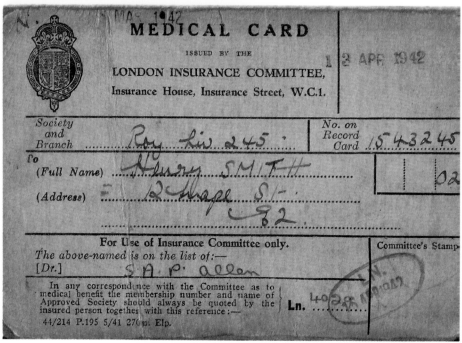

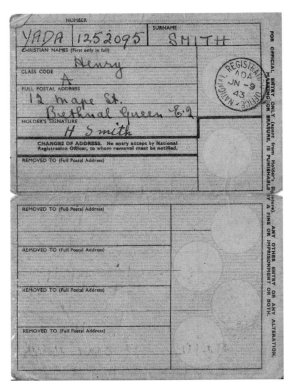

Henry Smith's national identity card. You had to carry these cards around in case you were asked for identification by a police officer or someone from HM Armed Forces.

NATIONAL SERVICE (ARMED FORCES) ACTS.

GRADE CARD

Registration No. _BIP 5504_

Mr _Henry SMITH_ whose address on his registration
card is _Epwell Mill Nr Banbury Oxon_
was medically examined at _OXFORD_
on _18 11 41_ _OXFORD_ and placed
in GRADE IV (FOUR). _MEDICAL BOARD_

(Medical Board stamp.)

Chairman of Board _R. Gordon Miller_

Man's Signature _H Smith_

N.S. 54.

(*6427—59 8) Wt. 31705—4423 50,000 11/40 T.S. **677**
(*6729—59 8) Wt. 39611—18 50,000 1/41 T.S. **677**

Henry Smith's National Service Armed Forces grade card.

Henry Smith in his Army uniform with his Army work colleagues.

Henry and Ethel in their pub, the Bishop Bonner, with relatives and friends.

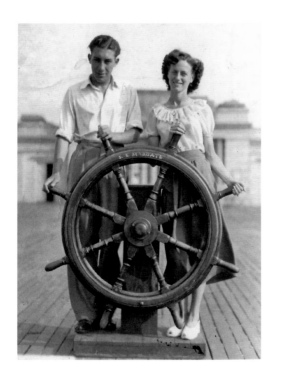

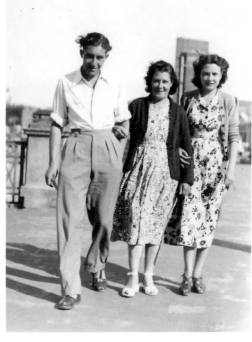

Henry and Margie on their day trip to Margate, August 1949.

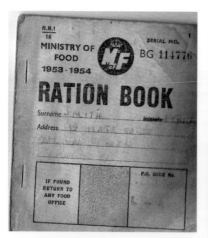

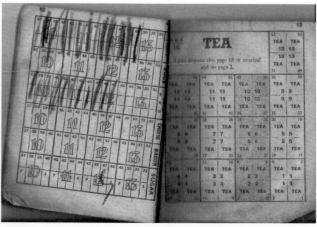

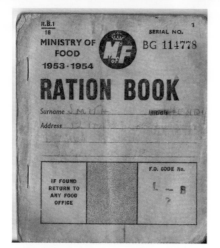

Above: The outside and inside of Ethel Smith's Ministry of Food ration book from the years of 1953–54.

Left and below: The outside and inside of Henry Smith's Ministry of Food ration book from the years of 1953–54.

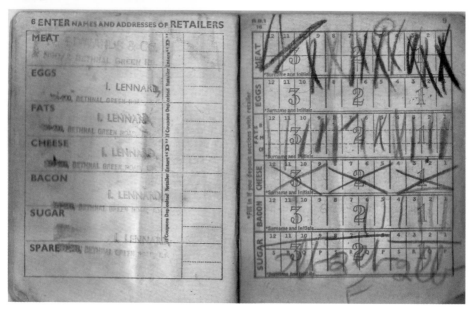

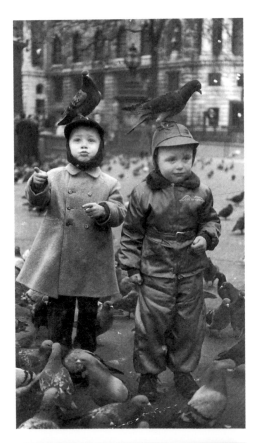

Stephen and Geoff on a day trip to
Trafalgar Square.

Cousin Ethel, a relative of Michelia's family.

Not long after my parents got married they moved back to Italy to Milan. My dad owned a big distiller in Milan that used to do a drink similar to Amaretto. Ironically, my great-grandfather created the recipe for Amaretto. While my parents were living in Italy they had me. I was born in December 1966. My nan was a dressmaker and she made my mum's wedding dress as well as the bridesmaids' dresses.

When I was four years old we moved back to England because my nan had a heart attack, and basically from then on my father started importing wine and spirits to England. As I got older I started on the market stalls alongside my mum. Since then I've always really been on the markets. I started on the stalls when I twenty during 1986. When I was twenty-two I gave birth to my son.

During the late eighties and nineties the markets back then were majorly different! They were seen to be more of a community. Whereas, before say you had a customer and they were 'thieving' and another trader witnessed it they would go 'OI!', now they would sort of let things slide. No one sticks together like we used too. Market stallholders would rather drop you in it than help you but when other traders want help they will try to rally everyone round by saying 'support us we need your help' but it does not work the other way round. That's the only thing that has really changed!

It used to be that older people on their own would come out and have a chat with you and it broke their day up. For example, an old girl used to come round to have a chat as if you were going to a hairdresser. You'd spill beans because they're never going to know the same people. So it's a confidentially sort of thing. That's how the markets used to be, but unfortunately they are not like that now. However, with our stall that's what we try and do to keep up that connection with people. This is what we are losing now in the East End – the connection between different people. The old ways of helping each other out.

The sense of community has disappeared. Bethnal Green is the only place in the East End that has kept that little bit of community spirit of the old East End. There is something about Bethnal Green that gets into your heart. 'You can take the girl out of the East End, but you can't take the East End out of the girl.' This is what we don't want to lose, we want to try and keep a bit of the East End the way it used to be.

Well, years and years ago, when the bombs were all going off, the people who did not have an Anderson shelter at the bottom of their garden used to go to the nearest Underground station. Years and years ago people used to pack up all their bags and the air raids used to go off and people were jumping out of their beds with their bags in their tracksuits. There was a bit of elastic around the waist so they could put their attire on quickly to get out and so they all used to visit the Underground for the shelter. But if you were to walk up to Bethnal Green station there is a plaque there where a panic broke out and everyone got crushed so people lost their lives down there. So my grandad built an Anderson shelter at the bottom of his garden but he would never go in it. He suffered from claustrophobia so while all the air raids and bomb alerts were going off he would sit outside with his wood pipe smoking while all of the kids were bunkered in the shelter.

My grandfather was a bit of a hooker and diver as most people were back then as it was a case of survival. It's funny because most people used to stick to their areas back then and what he used to do as he got a bit older was to look through the deaths for the rich people up the West End. He used to go up there and buy the stuff that they wanted to sell so then he went from the rag-bone to the diamonds, the coins and everything. George Rankins used to

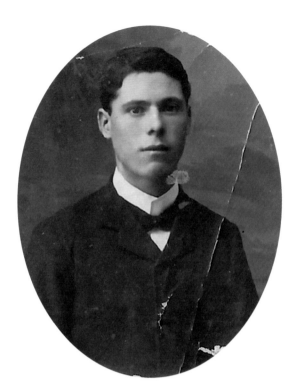

In memory of A. A. Morgan, Michelia's great-uncle, who served in the First World War, 1914–18.

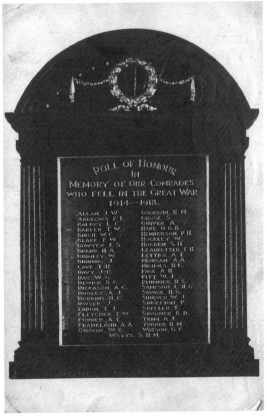

ROLL OF HONOUR
IN
MEMORY OF OUR COMRADES
WHO FELL IN THE GREAT WAR
1914–1918.

ALLAN, J. W.	GOODWIN, H. M
ANDREWS, F. L	GROSE, S
BALDEY, L. C	GUIVER, A
BARKER, T. W.	HARE, D. G. B
BIRCH, W. C	HENDERSON, P. H
BLAKE, F. W.	HOCKLEY, W.
BOWYER, E. S	HOGBEN, S. H
BRAND, H. A	LEADBETTER, F. H
BRIMLEY, W	LETTICE, A. E
BUNNING, J	MORGAN, A. A.
CAVE, T. H	NICHOLS, H. C.
DAVY, J. F.	PAGE, A. H
DAVY, W. G.	PITT, W. J
DEWICK, S. G	PLUMMER, H. S.
DICKASON, A. C	SAMPSON, L. H. G
DOOLEY, A. J	SAVAGE, H. G.
DORKINS, H. C	SHULVER, W. J
DWYER, T. J	SINGLETON, P.
EBDON, T. J.	SPELLER, R
FLETCHER, F. W	SPOONER, R. D
FORDER, A. E	TRIM, A. J.
FRANKLAND, A. A.	TURNER, H. M
GIBSON, W. E.	WATSON, G. F.
	WATTS, S. H. M

Roll of Honour in memory of the comrades who fell in the First World War. Look carefully and you can see A. A. Morgan's name listed.

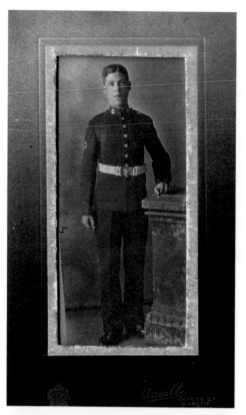

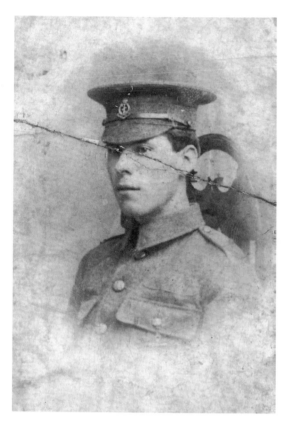

Above: A. A. Morgan wearing his Army uniform.

Left and below: Private Arthur Albert Morgan, who fought for his country, was killed in action on 17 June 1915, aged twenty-six years old.

— *For his country's sake.* —

Take comfort, ye who mourn a loved one, lost
 Upon the battle-field,
Thank God for one, who, counting not the cost,
 Faced death, and would not yield ;
Thank God, although your eyes with tears are dim,
 And sad your life, and grey,
That, howsoe'er the battle went, for him
 'Twas Victory that day !
With armour buckled on, and flag unfurled,
 The heights of death he trod,
Translated from the warefare of the world
 Into the Peace of God.

 He has gone and we shall miss him,
 But like him we must be brave,
 For he lies like many others
 In a British soldier's grave.

In Loving Memory

OF

Private ARTHUR ALBERT MORGAN,

R.A.M.C.,

Killed in action June 17th, 1915,

AGED 26 YEARS.

Royal Army Medical Corps,

Record Office,

Aldershot. 16......8..........1915.

Madam,

 I am directed to inform you that the following particulars have been received regarding the Burial Place of the late No. 682...... Rank. Pte...... Name. A. A.Morgan.............. Royal Army Medical Corps.

Buried at the Dressing Station in Zillibeke Village. No Chaplain Officiated. Service read by J. M. Forsyth, Medical Officer 1st Battn Cheshire Regiment.

 I am,

 Madam

 Your obedient Servant,

 Colonel.,

Officer i/c R.A.M.C. Records.

Letter received from the colonel of A. A. Morgan's serving regiment, the Royal Army Medical Corps, about his burial.

War Office,

Park Buildings,

St. James's Park,

London, S.W.

25th October, 1915.

E/ 121346 / 1 (Accounts 4.)

Madam,

In reply to your letter respecting the
estate of your brother, the late No. 682, Private
A. A. Morgan, Royal Army Medical Corps, I am directed
to inform you that your Certificate of Marriage and
the private letters which were forwarded to this
Department by the Controller, Post Office Savings Bank,
West Kensington, W. have been returned to him with the
necessary Certificate of Death, and the copy of your
late brother's last Will, and no doubt the documents
you require will be sent back to you in due course
from that Department.

I am,

Madam,

Your obedient Servant,

L. Miles

for the Assistant Financial Secretary.

Letter received from the War Office about A. A. Morgan's death.

business with him years and years ago buying their old coins and jewellery. The rich people used to say 'oh I don't need this', but it was worth thousands. My grandfather used to haggle and say 'awe it's only worth a shilling babe'.

Years ago, when people used to move into their houses in the East End, they used to give them a box to keep inside their new home. Inside the box they used to put a bit of bread, a lump of coal and a shilling. What they used to write at the bottom of the box was 'never be hungry, never be cold, and never be broke'. So what they used to do was put it somewhere safe inside the house and keep it forever. Our family were very much traditional and we still sort of are. Considering I'm an only child and Michael's (also known as Mickey Flanagan) family is quite big, we are all quite close. It is like having brothers and sisters. We are all still on top of each other and we speak at least once a week.

My nan was a cantankerous character. When she used to go to Southend she would sit down in the deckchairs and she'd get fed up with the sand. So she used to sit on a bench or wall. One time this woman walked past with a skinny dog. What my nan used to do with her cat if she was playing was to grab hold of its tail and flip it over. So she grabbed this dog's tail as they past and the woman said 'would you like me to do that to you?' My nan went 'you would have a great job cause I haven't got a bloody tail'. She wasn't a horrible person, she would do anything for anyone, but what was on the lung was on the tongue. She didn't hold any airs and graces, she was like she was.

My nan was one of the first people in Bethnal Green to have a television, so my grandad used to say Ethel put the television in the other room because it would be positioned well there. But my nan used to say no if we put it in the main living room when we open the windows the kids could watch it from the street. When they were evacuated in the war my Nan made sure the kids were not split up and stayed all together. They moved to Braintree in a big house out there, a large doctor's house, basically a mansion. It had a swimming pool but during the war you could not fill it up because of the water shortage. My nan became the cook and maid down there so she could keep the kids together. Once a week my grandad used to come up and visit and take a load of supplies up there that he got off the black market, so my nan used to make bread puddings, spotted dick, etc. Then she took it up to the main house and clarified what she had made and thanked them for letting us stay there. The woman who owned the house, who was a doctor, turned round and asked my nan how she'd managed to make such lovely cakes when we were all on rations. 'Where do you get these raisins, currents and sugar?' My nan replied, 'Ask no stories and you will hear no bloody lies. Just eat it and enjoy it.' They were all happy they got fed, the kids were together and my grandad did what he had to do for them to survive.

Years ago the café owned by the Pelliccis happened to be the place were the Krays used to do their business meetings before the bobbies were walking the beats. Back then my uncle came into possession of a few stolen televisions (how the lifestyle was back then) and he was selling them in Bethnal Green. The Kray twins got wind of him doing business on their turf and demanded that he shared 50 per cent of his earnings with them. My uncle told them where to go because they were not profiting anything from his income. Funnily enough the twins respected my uncle for sticking up for himself, because although they knew people, so did my uncle.

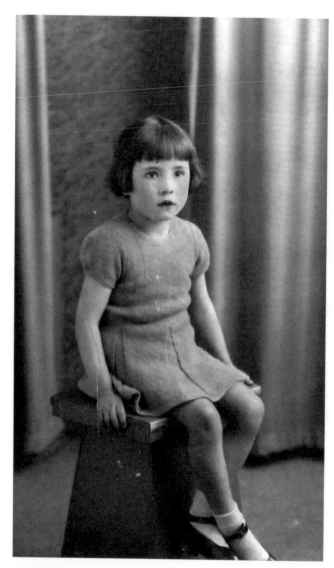

Left: Sylvie Smith, Michelia's aunt (Mickey Flanagan's mum), as a little girl.

Below: Shirley Smith's ration book. Food rationing began in 1940. This meant each individual could buy only a fixed amount of particular foods each week. Rationing made sure citizens got a fair share of food. During the forties you had to hand over coupons from your ration book, as well as money, when you went food shopping. For example, if you had used up your ration of one food, say cheese, you could not buy any more that week.

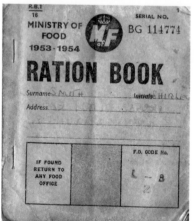

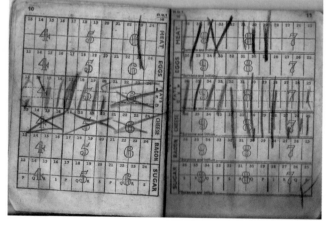

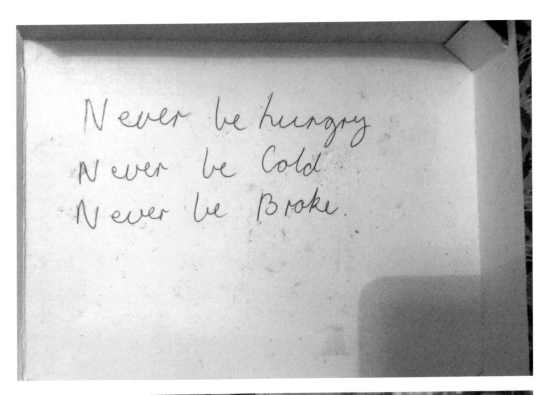

Never be hungry
Never be Cold
Never be Broke.

This is an example of the box East Enders used to create with the saying 'Never be hungry, Never be cold, Never be broke' with a piece of bread, a lump of coal and a shilling. They used to give this box to their family and friends to keep in a safe place when they moved into their new houses.

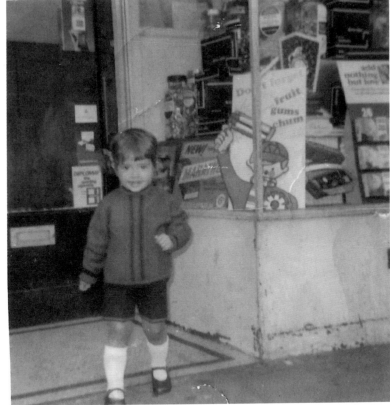

Michelia pictured alongside her Uncle Jack at Christmas time during 1967/68.

Michelia alongside her grandad at Southend-on-Sea beach enjoying the summer sun of 1967/68.

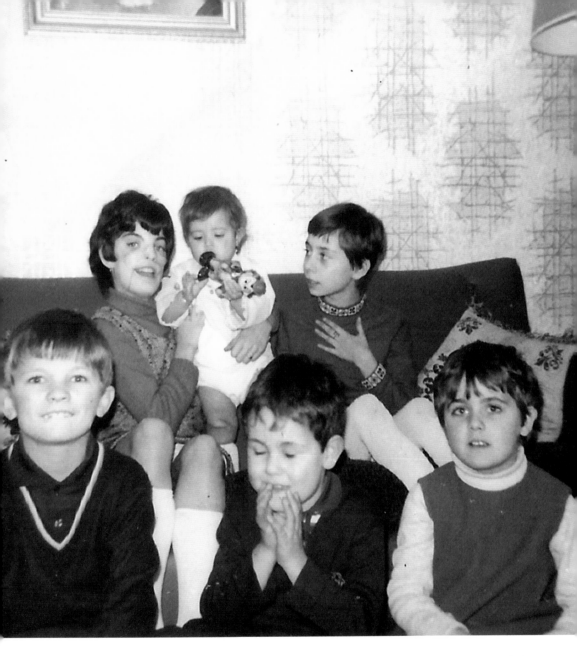

A photograph of Michelia's cousins. Front row in the middle is Mickey Flanagan, alongside his brothers and sisters.

Acknowledgements

I would personally like to acknowledge and thank all the contributors who helped me to create *Vanishing East End*. Sharing their memories, pictures, experiences and thoughts. This book wouldn't have been possible without the amazing collection of stories and photographs. This book portrays that the East End of London is a changing and dynamic part of London. The East End legacy and spirit will always live on!

Megan Hopkinson